# Less Is More

This book is dedicated to Erik Nitsche and Gene Federico

# Less Is More  The New Simplicity in Graphic Design  Steven Heller and Anne Fink

North Light Books
Cincinnati, Ohio

Acknowledgments

We would like to thank Lynn
Haller, our editor at North Light
Books, for the support and
encouragement she's given
throughout the planning and exe-
cution of this book. Without her
this would not have been possible.
Gratitude also to Linda Hwang
and Donna Poehner for their
invaluable editorial assistance.
We are also grateful to James
Victore for his splendid design
and for his good humor during
the excruciatingly difficult job of
organizing the massive amounts
of material provided to him.

Of course, this book would only be
an idea if not for the cooperation
and generosity of the many partic-
ipants. This kind of undertaking
requires a major effort of locating,
requesting and receiving materials
for consideration. First, we appre-
ciate the submissions by those
whose work was regrettably not
selected. Second, we owe a debt to
those whose work is represented.
And, finally, thanks to those in the
case study section who spoke with
us and answered our interminable
questionnaires.

Steven Heller and Anne Fink

Library of Congress Cataloging-in-
Publication Data

Heller, Steven.
      Less Is More : the new simplicity in
graphic design / Steven Heller and Anne
Fink. — 1st ed.
            p.   cm.
      Includes index.
      ISBN 0-89134-899-9 (alk. paper)
      1. Commercial art—United States—
History—20th century. 2. Graphic arts—
United States—History—20th century.
I. Fink, Anne.  II. Title
NC998.5.A1H45   1999     99-22715
741.6'0973—dc21                    CIP

Edited by Lynn Haller, Linda Hwang and
Donna Poehner
Production coordinated by Kristen Heller
Cover and interior designed by
James Victore Inc.
Design assistant: Morgan Sheasby

The permissions on page 154 constitute an
extension of this copyright page.

# Contents

Introduction                     6

That Old Simplicity            10

The New Simplicity             24

Advertising                   26

Annual Reports                34

Book Covers and Jackets       44

Books                         54

Catalogs and Brochures        64

Music                         76

Identity                      84

Magazines                     94

Packaging                    104

Posters                      114

Case Studies                 124

Dance Ink                    126

Chicago Board of Trade       130

Benefit                      134

Jerry Kelly                  138

The New York Times Magazine  142

Michael Ian Kaye             146

Hoefler Type Foundry         150

Copyright Notices            154

Subject Index                156

Index of Design Firms        158

Index of Clients             159

# Introduction

**There's a Movement Underground**
Design Firm: David Carson Design
Creative Director: Mike Jurkovac
Designer: David Carson

*Emigre No. 39*
Design Firm: Emigre
Designer: Rudy VanderLans

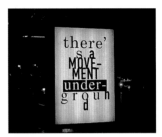

**Emigre no. 39**

Graphic Design and the Next Big Thing

**Price: Seven.ninetyfive**

Every era of graphic design has its own defining characteristics that signal the time and place of the work's creation. Since the late eighties, visual clutter has reigned supreme. This is not the first time that emphasis on decoration has dominated, but the clutter from this period is unique. The multiple layers of type and image found in contemporary design are, at least partially, a response to popular culture's visual density and, therefore, are a metaphor for the bombardment of words and images on television, video and the street. It is also a reaction to the previous generation's clean and rational "late modern" methods, deemed unresponsive to current aesthetics.

Perhaps most important, this clutter echoes technological advancements that have exerted an immense impact on both the production of and the concept behind graphic design. Yet should the responsibility for this visual clutter reside entirely with the computer and those influenced (or seduced) by its applications? Or was the computer introduced just when designers were ready for a shift from "less is more," the modernist maxim, to "more is more," the postmodernist penchant?

**Minnesota Children's Museum**
Design Firm: Pentagram Design
Designer: Michael Bierut
Client: Minnesota Children's Museum

Tracing the origins of graphic design style takes various routes. One reason for change is zeitgeist—some current in the air prompts shifts away from one style towards another. The airborne theory does not, however, explain exactly the whys and wherefores for specific changes. So one turns to the action/reaction theory, which suggests that for every dominant trend a countervailing rebellion eventually dominates. This fails, however, to precisely explain why particular typefaces or formats become paradigms of an era. So one may subscribe to the alpha theory, which proposes that key individuals lead the way while others follow. Obviously, change requires a combination of these factors—something in the air at a charged moment in time influences an alpha designer to create something that has a snowball-like effect on the design culture.

For over a decade the tendency, particularly among younger designers, to practice "more is more" in graphic design—which, among other labels, is called "new wave," "deconstructive," "punk," and "retro"—was a rebellion by one generation who sought to disrupt the status quo of the previous generation. It would have occurred whether the technology was in place or not, but the computer tipped the scales of change, giving designers the tools to make both elegant and convoluted complexity, depending on their respective levels of taste and talent.

Accepting the action/reaction theory, it should come as no surprise that once complexity achieved currency, becoming a code for youth culture, that alpha designers would begin seeking out alternatives. Simplicity, economy and reduction is one such alternative, not only as a rejection of fashion, but to enhance effective communication. And so goes the swinging pendulum. Excess, once a statement against conformity, has become a cliché. Indecipherability, once an argument against the antiquated tenets of legibility, has become a period trope.

The return to a "less is more" aesthetic is not eventually going to evolve into a style of redundancies. But for the moment simplicity offers at least as many variations as complexity. And what this book shows is how a new sense of economy (whether classical, modern, or contemporary) is investing graphic design of the late nineties with new possibilities. So what does "less is more" mean today?

The presumption that simplicity is pure functionalism is erroneous. The examples in this book range from stripped-down purity (Michael Ian Kaye's book jacket for The Dial Press, page 146) to what might be described as complex simplicity (Art Chantry's record album cover for Pigeonhed, page 80). Many points of view (and styles) are covered from the traditionalism of Jerry Kelly's book designs (page 138) to the postmodernism of Adams Morioka's poster for Slamdance International Film Festival (page 114). "Less is more" may be the absence of unnecessary complexity, while retaining design elements that further effective communication. What this work reveals is that "less is more" is not an overriding style, but the sum of many points of view. While there are certain common characteristics, such as a return to white space and reprises of classical and modern typefaces, this does not preclude a great variety. Simplicity means a return to basics but not at the expense of excitement.

**Etec Systems 1996 Annual Report**
Design Firm: Cahan & Associates
Designer: Lian Ng
Client: Etec Systems, Inc.

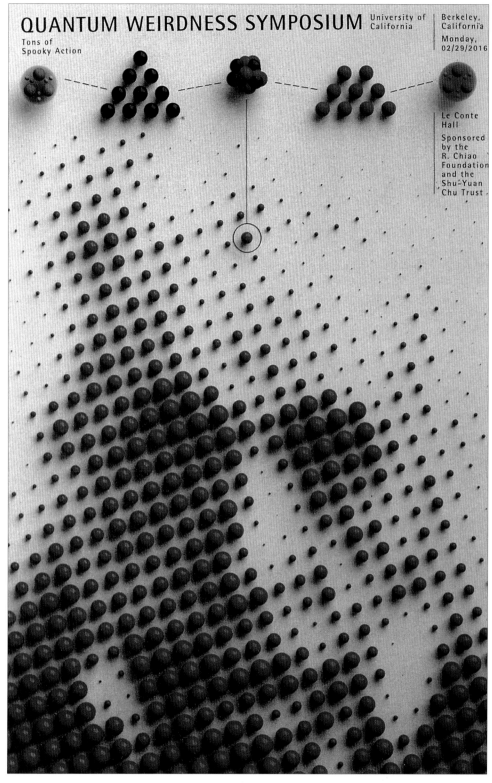

QUANTUM WEIRDNESS SYMPOSIUM University of California | Berkeley, California Monday, 02/29/2016

Tons of Spooky Action

Le Conte Hall

Sponsored by the R. Chiao Foundation and the Shu-Yuan Chu Trust

**A Design Resource**
Design Firm: Doyle Partners
Creative Director: Stephen Doyle
Designer: Andrew Gray
Client: Cooper Hewitt National Design Museum

**U&lc Bodoni**
Design Firm: Roger Black Inc.
Art Director: Roger Black
Designer: Paul Barnes
Client: International Typeface Corporation

**Quantum Weirdness Symposium**
Design Firm: Sagmeister, Inc.
Creative Directors: Janet Froelich,
Stefan Sagmeister
Art Directors: Joele Cuyler,
Stefan Sagmeister
Designers: Stefan Sagmeister, Veronica Oh
Digital Art: John Kahrs
Client: *New York Times Magazine*

# That Old Simplicity

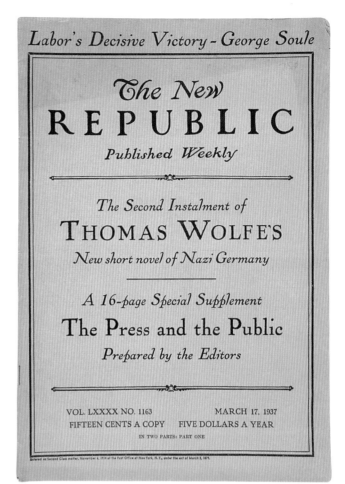

The maxim "less is more," coined by architect Meis Van der Rohe in the thirties, is an idea that dates back millennia. Van der Rohe was something of a classicist. The only difference between him and the architects of the fifth and fourth centuries B.C. was a sensibility and style born of the machine age. Van der Rohe was an artist of his time, but the fundamental tenets that guided his work were the same as those that governed his ancestors. Balance, harmony and simplicity have long been cornerstones of artistic activity, whether referring to ancient Greeks and Romans or modern Europeans. Aspiring to an emotional and physical equilibrium, which is rational rather than intuitive, means that even abstract compositions made up of cleanly defined geometrical shapes express classical principles of restraint and order.

This is the essence of all design. And yet for every classicist an anticlassicist argues that restraint is not a virtue but an impediment against intuitive expression. The histories of art and design are replete with epochs, movements and styles that employ clutter as an ideological or aesthetic reaction to purity.

The contrarians believe that the idea of "more is more" is decidedly better than the alternative. Of course, one person's clutter is another's order. What appears chaotic on the surface could very well be systematic underneath. One can certainly argue that purity is not always as rich in meaning as multiple levels of visual experience. Moreover, certain kinds of themes and subjects are better communicated through complex applications of type and image. In his introduction to *Printing of Today* (Harper and Brothers, 1928) the novelist and printing aficionado Aldous Huxley recalls a rather eccentric German typographical reformer "for whom legibility is the great enemy, the infamous thing that must at all costs be crushed. We read, he argues, too easily. Our eyes slide over the words, and the words, in consequence, mean nothing to us. An illegible type makes us take trouble. It compels us to dwell on each separate word: we have time, while we are deciphering it, to search out its whole significance."

Simplicity is usually synonymous with legibility in graphic design, and yet legibility is not always the most effective (or eye-catching) way to communicate. Defining legibility solely as a message void of obstacles is not entirely correct, either. An uninterrupted page of text, for example, may be clean, but uninviting. Monotony ultimately hinders retention and without navigational aids (bold face type here, italics there, even a strategically positioned rule, fleuron, or illumination) the eye can become as weary as a driver on a long stretch of continuous highway. And just as the car ride can be made more pleasurable by diversions, sometimes messages are made more enjoyable, and are better remembered, when deciphered through layers of image and text. Sometimes a little struggle is not a bad thing. Yet generalizations of this kind are easy to make and hard to quantify; the merits of simplicity or complexity really depend on specifics, like the nature of the message and the audience at whom it is aimed. Nevertheless, some designers are vociferous proponents of simplicity, others are against it. Throughout the annals of twentieth-century graphic design these polar opposites have defined the styles of respective times.

## The Simple Truth

Graphic design originated as complexity and over time was reduced down to fundamental, or what the twentieth-century European moderns called "elementare," or elementary, form. Ever since 1455 when Johannes Gutenberg introduced the first moveable type in the printing of

his forty-two-line Bible, printers (and later designers) have confronted the problems of simplicity versus complexity. Gutenberg's Textura (or gothisch) typeface evolved into the Germanic blackletter types, which from the fifteenth to early twentieth centuries tested the limits of sustained legibility—and ultimately fostered a typographic rebellion. In 1470, however, the Venetian printer Nicolas Jenson cut the first Roman type, based on rubbings taken from an inscription on the Trajan column in Rome, recognized as the fount of typographic purity. Rooted in Italian humanism, the Roman capital letter is rational, balanced and graceful. Its foremost interpreters, from Geofroy Tory to Stanley Morison, have described it as the quintessential letter based on geometric precision—unsurpassable in its perfection. The blackletter or gothic, by comparison, has been referred to as a degenerate form that obstructs comprehension. Yet it was the letter of choice for Germanic peoples for centuries to follow, and so was perfectly decipherable to those familiar with its form. In contrast to the spiky German blackletter designed after the renaissance, known as fraktur, the often critical traditionalist Stanley Morison wrote that "no roman type has been designed in Germany which...produces the factors of economy, legibility and suitability for the German language."

From the sixteenth century, when humanist type designers like Claude Garamond sought to define "ideal letterforms" born of what Jan Tschichold described in *An Illustrated History of Writing and Lettering* (Columbia University Press, 1948) as "extreme regularisation on geometrical principles," to the late nineteenth century, when William Morris revived incunabula (the earliest known printed material) as an alternative to what he believed was monotonous traditionalism, the main bout in design has been a slugfest between complexity and simplicity. Graphic design history is characterized by the ebbs and flows of less and more.

## More Bang, Less Nuance

By the late nineteenth century, when the nascent profession of commercial art was still the province of printers, and the skilled craftsman called a typographer did not yet exist, typographic purity was not a major concern. Achieving more bang for the buck was the goal. And judging from the trade journals and type specimen books of that era, although legibility was a factor, simplicity was not usually the means to that end. The posters, broadsheets and handbills that characterized a Victorian graphic

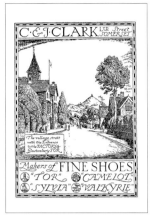

**Makers of Fine Shoes**
Clark Fine Shoes
Advertisement, 1925

*American-Chap Book*
Pamphlet, 1918
Designer: Will Bradley

style were raucously cluttered with variegated wood types of different families and weights. Rather than following a predetermined design scheme, this was an ad hoc "look" born of necessity and intuition. Printers did not always have full fonts of particular alphabets and they flagrantly mixed and matched different letters as needed. These discordancies were, in fact, eye-catching, and the louder the typographic scream, the more the public paid attention. Invariably, the more attention, the happier the client.

The late nineteenth and early twentieth centuries were periods of boisterous advertising displays made from novelty typefaces with slab serifs and serpentine swashes. Ostentatious letterforms were often exaggerated versions of classical ones, expanded, condensed and distorted to grab attention. This was the era of more: more decoration, more ornament, more filigree and more bravado in layout and design. Poster hoardings and newspaper advertising sections were cluttered with typographic material, yet excess ultimately hindered effective communication. Conformity bred confusion. And when any style dominates the landscape, distinguishing one message from another or one product from the next is as difficult as picking a face out of a crowd—it can be done but requires more concerted attention. Such was the predicament during the end of the first decade of the twentieth century, when commercial markets expanded and advertising grew more unruly, requiring that typography be governed by aesthetic standards. The need to shift gears resulted in the preference from more to less.

## On the Barricades

Radical experiments in modern painting prior to and resuming after World War I prompted paradigm shifts in graphic design. Inspired by cubism, futurism and constructivism, progressive commercial artists saw an opportunity to challenge antiquated practices and thus develop design styles that were distinctly of their time, rather than mimicking previous ones.

Experimental (or unconventional) design developed in Russia, Italy and France, yet the most significant changes occurred in war-ravaged Germany, where prior to the outbreak of hostilities typography and layout had devolved into a melange of unnecessarily rigid rules and conventions that were unresponsive to contemporary aesthetic and commercial needs (as well as symbolic of a repressive political situation).

Liberating German design from the strictures of blackletter typography and centric com-

position was the first step in an effort to simplify the commercial arts and make them more dynamic. Although change did not happen overnight, or in every print shop and design studio throughout Germany, a typographic revolution had begun to take hold. Postwar Germany was in the throes of political, financial and cultural chaos, and while in the best of times it would have been difficult to alter centuries of tradition, in the worst of times it had a fighting chance.

The assumption that simplicity might help restore a modicum of order at least to the visual and industrial arts inspired designers to strip away the veneers of ostentatious convention. Accepting mass production (as opposed to handicrafts) as the cornerstone of an industrial economy was another factor. Modern German designers, influenced in part by the purity of Dutch de Stijl and the purism of Le Corbusier, embraced geometry as the holy grail of design. The Bauhaus, the state arts and crafts school founded in 1919 on an expressionistic (and somewhat mystic) foundation, evolved into the vanguard of a new rationality, marked by the rejection of ornament in favor of elementary form. For graphic designers this meant removal of superfluous accouterments common to most print advertising at the time, including decorative borders, frames and fleurons. The result was not simply design stripped down to bland type and image, but rather an entirely new and dynamic form language.

"Elementare Typografie" (Elementary Typography) or the new typography, as it was also known, was a contemporary design system based on asymmetrical composition, pure geometrical forms, sans serif letters, bold rules, white space and the color red. With these elements a designer had a wide range of tools with which to compose functional design. And yet the word reductive did not imply stagnant. On the contrary, proponents of the new typography argued that older methods had reached a dead end—and the public had become oblivious to the tried and true. Mainstream advertising could greatly benefit from rejuvenation and so radically reduced compositions starkly stood apart from fussy, decorative design. An exhibition of reductive commercial design organized by the Circle of New Advertising Designers revealed not only that the new form language was so much more exciting than conventional approaches, but also that its functionalism made promotion and publicity more accessible.

Designers invariably sought ways to expand the vocabulary of the new typography, and those

**Fall and Winter Hats series**
Advertisements, 1918
Designer: Will Bradley

who were eager to avoid recurring habits and stereotypes developed new ways of using the additional design forms. Within the framework of rules established by the proponents of the new typography, graphic design was gradually becoming more complex. While layouts were not burdened with unnecessary scribbles and scrawls, use of color bars and type blocks were becoming more intricate. Nevertheless, at the same time a reaction to progressive design began to grow within those segments of commercial art that felt elementary form lacked the allure that had previously appealed to the masses. They wanted to know why design had to be so austere. Why couldn't it be modern and have flourish too?

## Down With the New, Up With the Newer

A modern home designed with a flat roof and perfect 90-degree angles (the paradigm of modern architecture) was criticized as colder and less hospitable than one with a pitched roof and irregular nooks and crannies. This analogy was aptly applied to graphic design insofar as a page without an iota of irregularity was not as inviting as one with quirks. Although mass taste was decried by progressives as a bourgeois sensibility, it was nonetheless the dominant sensibility which had to be addressed. The masses might have wanted simplicity in their personal, social and political lives, but their design was a different story. They preferred comfort and they wanted complexity. Therefore, graphic design of the early thirties ultimately fell into two basic categories: modern and moderne (or modernistic); the former was void of unessentials and appealed to cultured sophistication, while the latter reveled in style and fashion.

Modern design exerted an influence on and provided templates for modernistic design—asymmetry was retained but decoration returned, albeit in a streamlined form. Graphics did not entirely revert back to the ostentatiousness of the Victorian or even the subsequent Art Nouveau eras, but austere reduction was perceived as a code for political and cultural radicalism and therefore rejected. For the masses to truly accept modernism it had to be filtered through their tastes. Moderne design was modern without the sharp edges, and over time modernistic quirks (geometric dingbats and ornaments, for example) acquired popularity. By the mid-thirties, the bourgeois graphic style that took hold in most industrialized countries was less about simplification than about the inclusion of contemporary ornament printed in

bright colors. This trend further exacerbated the fundamental schism between those who swore allegiance to simplicity and those who did not.

In the end, however, both forms succeeded and failed. By the late thirties the new typography was the old new typography. The Bauhaus, closed by the Nazis in 1933, was no longer the major influence on European design (although in the United States the New Bauhaus was established in Chicago with a faculty of European immigrants who began to influence American advertising and corporate design). Yet some of the changes in attitude espoused by Bauhaus teachers—form follows function, for example—were assimilated into much broader realms of design thinking and philosophy.

## Simplicity Comes to a Head

World War II forced the issue of simplicity to a head because the privations of war demanded austerity in every facet of life. Wasting resources was not an option and therefore graphic design (like other commercial output) was reduced to its fundamentals. Perhaps this forced functionality gave rise to the postwar embrace of "less is more"—perhaps it was a catalyst for something that was waiting to happen. In addition to these social factors, schools of design and individual designers promulgated a "less is more" philosophy with something akin to religious fervor.

Beginning in the early forties and continuing well after World War II, designers who had been raised in or influenced by European modernism—notably Paul Rand, Leo Lionni, Lester Beall, Will Burtin, Alvin Lustig, Bradbury Thompson and Ladislav Sutnar—took on roles as missionary reductivists. Rand's earliest covers for *Direction* magazine and advertisements for Disney Hats, Kaiser Frazier automobiles and AirWick air freshener rejected conventional clutter for conceptual clarity that was imbued with wit and play. He reasoned that just because a visual message had multiple levels of meaning, it need not be weighed down by visual detritus. Rand introduced a method where simplicity was not a self-conscious trope, yet it was an integral part of an overall design scheme. Similarly, Lionni did not overburden his advertisements produced for the Container Corporation of America; Beall was direct in stark poster designs for the Rural Electrification Administration; Burtin clarified complex data in information graphics for *Fortune* magazine; Lustig employed simplified abstraction in book jackets for *New Directions*; Thompson made functionally elegant layouts for *Mademoiselle* magazine; and Sutnar invented ways to present dry information found

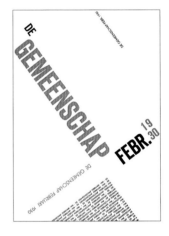

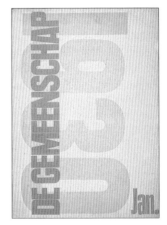

*De Gemeenschap*
Magazine covers, 1930
Designer: Paul Schuitema

in common industrial catalogs with functional dynamism—today they remain the cornerstone of the new field of "information architecture." Each of these designers proffered the belief that maximal impact can be achieved by focusing the viewer on an essential visual message.

Modernist notions of simplification had great influence during the fifties on graphic design employed by corporate America. Around the same time, an "international style" in Europe was building momentum as well. In postwar Europe few countries were as unscathed—or as prosperous—as neutral Switzerland. When the former belligerent nations began to revivify their respective economies, Switzerland was already the crossroads of international finance and in the vanguard of graphic design as a tool for industry. The Swiss style, alternately called the International Style or die Neue Grafik (new graphic design), was a synthesis of Bauhaus teachings and an atavistic Swiss sense of order. While American modern design was orderly, it was nevertheless rooted in individual intuition; Swiss modern was objective to a fault.

## Gridlocked

The principles of the Bauhaus evolved into a graphic style that was specific to its comparatively short time and place in history. The International Style was an extension of Bauhaus ideas and a tightening of the rules that governed them. The Bauhaus emphasized geometric composition, and the new typography set down strict layout guidelines, but the most important design contribution of the Swiss style was introducing the grid as a compositional system.

Prior to the emergence of the grid, layouts were made in an ad hoc way that resulted in an overall format established by a layout artist or printer, but often without a strict foundation. Therefore, contiguous pages varied from one to the next. A grid is like a flight plan, a predetermined set of parameters for the designer to follow. It is the codification of a format—an infrastructure, a template, and the invisible skeleton of a page (or pages) on which type and image are composed. The grid is a tool that insures an overriding consistency (such as the placement of page numbers, captions, headlines and indicates the spatial relationships between these). Yet grids are designed in various configurations with different internal options—one, two, three or more columns are all possible, with various combinations of column widths. Yet once the grid is determined, it requires total adherence.

The grid does not mitigate against the use of decorative material, but it reduces the tendency to use it. As practiced by orthodox Swiss and German modernists the grid insured simplicity and typographic order through hierarchies of design components. The design magazine, *Neue Grafik,* the baedeker of the Swiss style, was the foremost example of "gridlocked" design. Its black and white cover and interior pages, printed on glossy paper, were the epitome of graphic austerity. A single typeface, Helvetica in two or three weights, was used exclusively. Headlines and subheads were the same size as the body text with the relative importance of each determined by positioning on the grid. A headline did not have to be large, rather it might be bold or italic for it to be read as a headline. Stripped of all but the essentials, die Neue Grafik was the essence of graphic design purity.

Not only did the Swiss impose limited typographic options, they also abandoned conventional illustrative solutions, which arguably imposed an individual viewpoint that conflicted with a client's message. While an individual personality might give an advertisement or publication its distinct allure, Swiss designers believed that introducing subjective content distracted from clear communication. Proponents of the Swiss style argued that a graphic designer's task was solving business's communications problems by creating suitable design that was versatile, yet void of subjectivity. The postwar concept that graphic design is not merely rote layout but rational problem solving was formalized in Switzerland. In *The Graphic Designer and His Design Problems* (Hastings House, 1983), Josef Müller-Brockmann, one of die Neue Grapfik's leading proponents, wrote, "The graphic artist must have mental flexibility if his mind is to penetrate the never-ending sequence of problems he has to contend with." He added, "By discarding the old free subjective manner of representation, [the graphic designer] acquired freedom for a more highly charged organization of forms that were appropriate to the subject." Not only was simplicity a virtue of "objective graphic art," but Brockmann also wrote that "the more anonymous and objective these elements are the more suitable they prove as a vehicle for the thematic idea; the realization of this idea in graphic form is the end to which all the elements of design must be directed."

The Swiss landscape is very colorful, but the Swiss style is characterized by a severely limited color palette. Armin Hofmann—who, with Emil Ruder, was the force behind the Basel School of Design—created black and white posters to "counteract the trivialization of color as it exists today on billboards and advertising,"

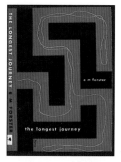

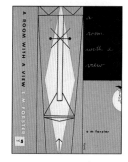

*Ecce Homo*
Book cover, 1921

*The Longest Journey*
*A Room With a View*
Book jackets, 1949
Designer: Alvin Lustig

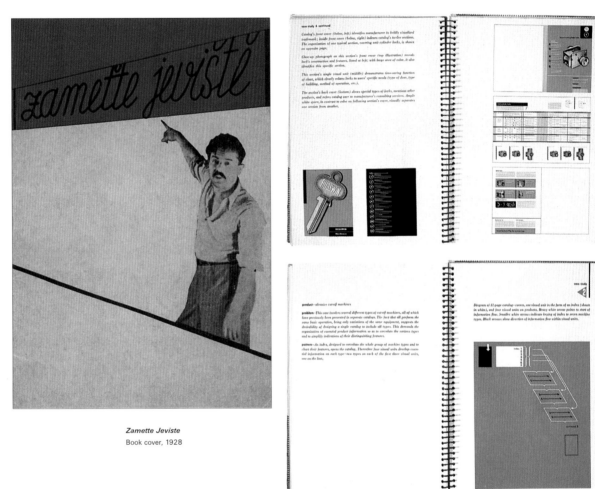

**Zamette Jeviste**
Book cover, 1928

**Catalog Design**
Brochure, 1953
Designer: Ladislav Sutnar

**Catalog Design Progress**
Book, 1954
Designer: Ladislav Sutnar

**Typografia**
Magazine cover, 1932

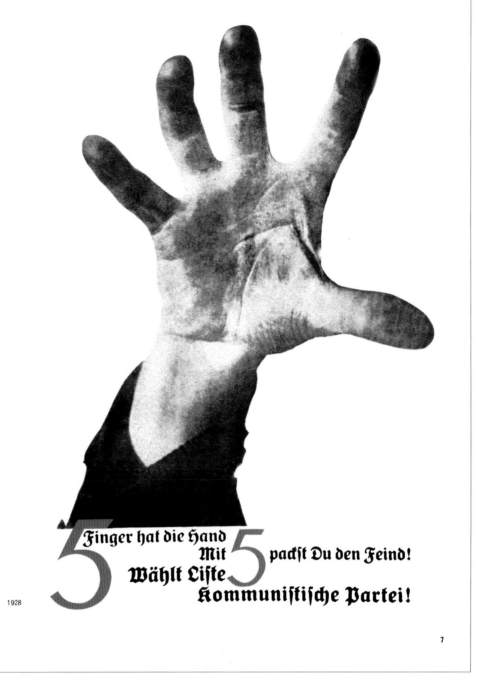

**Funf Finger hat die Hand**
Political poster, 1928
Designer: John Heartfield

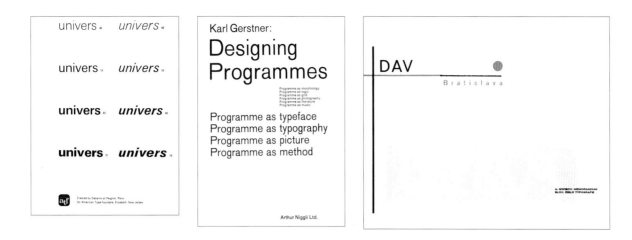

he explained in a speech at the Swiss Institute (1986). "Paradoxically, I believe that one is more likely to develop a better perception of color by looking at the subtle harmonies of black and white images than by looking at the multi- and overcolored illusions color photography often creates." Hofmann further stated that his posters are reminders that in affluent societies the tendency towards excess always exists within the mass media. "The idea of limitation or restriction, therefore, takes on new meaning," he continued. "In the realm of visual communication, excess of expense and pomp do not necessarily lead to gains in clarity." Equally important, Hofmann believed that abstract structure is the vehicle for communication, and so his approach is structural, or as Kenneth Hiebert wrote in *The Basel School of Design and Its Philosophy: The Armin Hofmann Years 1946-1986* (Goldie Paley Gallery, 1986): "It relies on analysis that rigorously questions and accounts for all parts of a message." Hiebert continues, "The act of searching for an appropriate structure forces the designer to make the most basic inquiry about an object of message, to isolate its primary essence from consideration of surface style. In this exhilarating but arduous process, the designer is engaged in defining meaning at both the simplest and most universal levels."

Type design was a major factor in promulgating what the Swiss asserted was a universal aesthetic. Sans serif alphabets were promoted in the twenties as the modern panacea for all aesthetic and functional ills. Futura—designed in 1925 by Paul Renner in Germany—was touted as the "type of the future," and it was the essence of simplicity. By the fifties, however, Futura was regarded as somewhat old fashioned and replaced by an even more neutral alphabet. In 1957 Adrian Frutiger designed Univers, a versatile sans serif typeface that came in twenty-one sizes (a total of 17,280 letters and punctua-

tion marks), many more than any previous typeface families. Emil Ruder wrote in *Neue Grafik* (1959) that Univers "has made use of forms which permit a rich interplay of visual effects." Today Univers is the sina qua non of sans serif faces both for its range of application and its unadulterated simplicity. But one other face epitomized the age. In 1961 Edouard Hoffman and Max Miedinger designed Helvetica, a perfectly balanced face with a small X-height that could serve in its bold weight as a striking headline or in its roman as a clear body type. It was neutral insofar as its basic form did not draw attention away from a message, and in short order Helvetica became the embodiment of the Swiss style.

## Functional Design Is Good Business

During the twenties progressive designers believed they were contributing to the social and cultural transformations of their respective nations—design was a vehicle that both advanced and symbolized change. By the mid-fifties designers were somewhat less utopian, but nevertheless believed that good design was good citizenship, and good citizenship was good business. If graphic designers wanted to avoid what Hiebert referred to as a "frivolous cluttering of the environment," their work could not be trivial in form or concept. Rational, objective and reductive design not only allows clear communication, but signifies social responsibility. Practically speaking, designers like Armin Hofmann believed that good design—clear, clean and orderly—must promote good works and products. By implication cluttered design obfuscates bad enterprises.

Unlike Hofmann's black and white posters, which are indeed poignant critiques of the culture of excess in modern life, the idea that reductive design is more socially valuable than the cluttered alternative is perhaps too black and

**Univers**
Type specimen, 1956
Designer: Adrian Frutiger

***Designing Programmes***
Book jacket, 1960
Designer: Karl Gerstner

**DAV**
Letterhead, c. 1927

white. One of the most orderly design systems of the twentieth century was developed by the Nazis. And later in the postwar corporate era the Swiss style was enthusiastically adopted by communications departments of most of the world's largest conglomerates, the business practices of which are not entirely paradigms of virtue. So while "less is more" implies a certain kind of responsibility, it may also serve a much less laudatory end.

By the late fifties and into the early sixties the reductive style was the popular approach to solving design problems, but it did not always stem from lofty moral roots. In American advertising, orthodox modernist ideology was not an issue; rather, designers accepted minimal design as the best means to frame "The Big Idea." In the early forties, Paul Rand launched a creative revolution in advertising that changed the fundamentals of print promotion from hard-sell to smart concept. Rand rejected the conventional copy-packed pitch cluttered with screaming headers and overly literal images, opting instead for generous white space and short pithy headlines. This approach, a radical departure from timeworn formulas, inspired "creatives" to practice advertising as a mixture of art and entertainment, rather than as hucksterism. By the mid-fifties Rand passed the baton of innovation to younger acolytes; art directors like George Lois, Helmut Krone, Bob Gage, William Taubman and Gene Federico designed advertisements incorporating reductive principles of the moderns with smart concepts. This was an era when the smartest ideas captured the most attention and the big idea could be manifest in words, words and image, or image alone. In addition, the introduction of conceptual studio photography made it imperative that typography did not compete but rather reinforced the big idea. Advertising, furthermore, needed to be distinct from editorial design (and vice versa). White space was a buffer that separated the advertisement from the editorial layouts. Advertising set the standards for "less is more" graphic design in the mass market.

In the corporate realm, reduction was essential for clear internal and external communications. The Swiss launched a corporate modern style, but the Americans exploited it to the fullest. Starting in the mid-fifties, American corporations were growing internationally at a quick pace. Graphic design was a means to manage the plethora of business materials— from letterheads to packages to manuals to signs. Major companies desired distinction, but they also required consistency within their pro-

grams, which necessitated simplicity and order. The design programs and the designers leading the way were, among others, General Dynamics (Erik Nitsche), International Paper (Lester Beall), and IBM (Paul Rand) and Westinghouse (Paul Rand). Each adhered to a system of rules used to govern designs that allowed for both variation and consistency.

Corporate modern, as opposed to earlier business graphics, eschewed archaic form. Logos, for example, were once illustrative marks, more like cartoons than symbols, featuring trade characters or stock cuts of globes, factories or classical figures. By the fifties, however, the superfluities were removed and abstraction was introduced. Among the most memorable for both simplicity and acuity are Paul Rand's Westinghouse logo, a *W* that evoked the image of a circuit board; Lester Beall's International Paper logo that resembles a geometric tree; and Chermayeff & Geismar's Chase Manhattan Bank logo that looks something like a bolt. By the early seventies logos were further abstracted into linear masses, notably Saul Bass's AT&T and Minolta logos that used motion lines to give the illusion of speeding spheres.

Corporate modernism evoked its time and place in the design continuum and signaled that corporations represented their times as well. Yet for all the innovations of the Swiss and American modern schools of design, the by-product was conformity. While the overall levels of graphic design proficiency (and awareness) were higher, nonetheless, the corporate style proffered redundancy. Simplicity was the panacea for visual confusion, but it was also a recipe for dull design. Helvetica grew like kudzu on every kind of generic corporate program. It was so widespread that certain programs were virtually indistinguishable from others. By the eighties Helvetica was the typeface of choice for generic supermarket packaging that was void of any brand character or identity. Ultimately, corporate modernism became an "official" style and, therefore, the enemy of designers who rebelled against the established order.

### Old Waves, New Waves, Next Waves

Postmodernism was the banner under which the anti-moderns (and unmoderns) massed. Originally developed in architectural theory of the late seventies as an alternative to the purity of the international style, postmodernism was quickly infused into many areas of art, literature and design, with the goal to replace so-called bankrupt style with culturally invigorated diversity. "PM" designers drew inspiration from

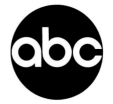

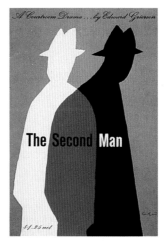

**ABC Logo**
Designer: Paul Rand
1961

*The Second Man*
Book jacket, 1959
Designer: Paul Rand
Publisher: Vintage Books

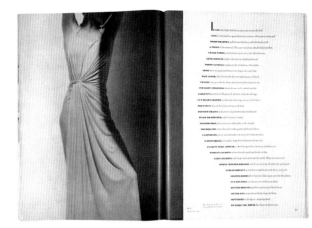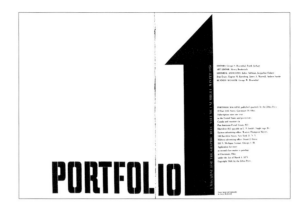

past and present styles and forms. Neutrality was no longer a virtue but rather indicative of the orthodoxy of the old guard. In graphic design, postmodern was a license to reclaim old styles for contemporary use and to extend the boundaries of design into uncharted areas.

Two fundamental postmodern points of view that challenged the "less is more" aesthetic were retro and new wave. Admittedly, this may be a simplistic reduction of the various period styles and methods, but these categories are broad enough to include many variants. Broadly defined, retro was the borrowing of design styles from the past. Although this was not an entirely new concept—in the late fifties Push Pin Studios reprised Victorian, Art Nouveau and Art Deco styles, spawning a revival that influenced many other designers—"new" retro references were different. Charles Spencer Anderson (then with the Duffy Group in Minneapolis), for example, laid claim to printer's stock cuts of the thirties and forties as the basis for a contempo style that was part camp and part serious form language; Paula Scher introduced the look of Russian constructivism and Dutch De Stijl to posters and record covers; M&Co invoked what it called "vernacular," the unsophisticated (non-design) design of sign painters and job printers to brochures and catalogs. Retro was at once nostalgic and revivalist—pastiche and exploration of passé forms. Designers borrowed their sources from what Tom Wolfe called "the big closet" of historical reference, including the Bauhaus, A.M. Cassandre, E. McKnight Kauffer, Dada, futurism, etc. In this way retro might be elegantly simple or raucously complex.

The new wave was more in sync with the moderns in its attempt to make design that was of its time and, therefore, its proponents engaged with the new technologies in pushing the accepted boundaries. The new wave was ostensibly born in Switzerland under the influ-ence of Wolfgang Weingart, a second generation proponent of the Swiss style, who after years of adhering to the grid busted out with a ven-geance. His typography was neither classical nor novelty but rather pushed the language of mod-ernism from neutral to boisterous. By using dif-ferent weights of sans serif type within a sen-tence or phrase, he enabled letters and words to have increased emphasis, indeed nuance, some-thing that the orthodox Swiss moderns avoided at all costs. On the surface, Weingart's typo-graphical compositions appeared complex, but in fact they were well-ordered hierarchies of mean-ing. Complexity was merely a by-product of deneutralizing the typography. Once the uncon-ventional pathways of comprehension were established in the minds of readers, the content was accessible and navigable. Weingart's stu-dents, notably April Greiman and Dan Friedman, further spread the gospel of the (new) new typography in the United States. Compared to the corporate modernism's quietude, the new typography (and in Greiman's case, her comput-er-aided collages) raised the visual noise to a high pitch. Yet despite the increase in volume, Greiman's and Friedman's New Wave, like Weingart's, exhibited vestiges of Modernist order, and was not as indecipherable as the next wave.

As though the pituitary gland had sprung a leak, graphic design from the mid-eighties through the early nineties quickly evolved into overwrought complexity. The reason was glan-dular in the sense that a younger generation of designers entered the field wanting to change the rules and establish its own paradigms. Progressive graduate schools, including RISD and Cranbrook, fostered hothouse conditions where these neophytes were free to experiment with new ideas and theories. Most significant, the computer was the single most important new tool of graphic design, and young designers

*Harper's Bazaar*
Magazine layout, 1948
Designer: Alexey Brodovitch

*Portfolio 1*
Magazine layout, 1949
Designer: Alexey Brodovitch

were finding ways to not only cope with its potential, but develop design languages that addressed new media, being of its time. Among the leaders, *Emigre* magazine, founded by Rudy VanderLans with Zuzana Licko in 1984, did for the next wave what Jan Tschichold did sixty years earlier for the new typography: It introduced experimental designers and showcased as well as pioneered new (often radical) layouts and type that reconciled the computer's limitations and wonders. Design complexity was not necessarily a conscious decision, but it was a natural outgrowth of *Emigre's* experimental program. Although much of VanderLans's and Licko's best work is precisely composed within parameters of their unconventional design method, much of the work that *Emigre* showcased reflected the raucousness that was beginning to surface from the hothouse schools and progressive design firms around the United States and Holland (which, incidentally, was the new hotbed of experimental design).

In the country known for its orderly landscape, which inspired Piet Mondrian to found de Stijl in 1920 and create geometric objectivist paintings depicting that order, Dutch designers in the eighties viewed the complex layering of type and image as a metaphor for the hustle of daily life. The marriage of intuition and theory that characterized contemporary Dutch design exerted an influence on students of the most progressive design school in America, Cranbrook Academy of Design. Cochaired by Michael and Katherine McCoy, the graduate course provided open studios for students to test theoretical principles related to composition, type, color and image, which ran counter to the orderly notions of late modernism. They also introduced to graphic design the postmodern idea called deconstruction—which is best described as the turning inside out of the infrastructure of design in order to explore the inner workings of a printed page, and then reassembling those components so that the skeleton of the page is on the outside. If this sounds somewhat obtuse, in theory it is the examination of what makes design tick. In practice it gave rise to a design style of a complex nature.

To explain this method, the proponents of deconstruction invoked contemporary literary and cultural theories concerning the essence and complexity of language. But to better understand the style, consider its roots in architecture, and take a building, like the Georges Pompidou Centre in Paris, where its infrastructure (girders, ducts, pipes, etc.), instead of being hidden behind the facade, is exposed for all to see.

Traditionally, a building's walls cover its inner works, but in the deconstructive scheme all manner of minutiae is revealed. Similarly, a deconstructed layout exposes the invisibles (the grid, crop marks, holding lines, etc). Initially an exercise in understanding composition, it became a tool used to critically comment on modern composition, and ultimately a design trope that flaunted rejection of same. Whereas "less is more" was the modern credo, the postmodernists literally exposed design as being more than meets the eye. Complexity was not merely a knee-jerk reaction to the past, but part of a critical discourse on the nature of visual communications.

In its formative stages, deconstruction attempted to explain the essence of graphic design. As it developed out of the classroom and into the mainstream it became a style. While VanderLans and Licko exhibited the experimental work in *Emigre,* David Carson, a self-described unschooled designer, put the experiments into practice, first in *Beach Culture* magazine (devoted to surfing) and then in *Ray Gun* magazine (devoted to alternative rock). Where *Emigre* reached a relatively small audience of graphic design aficionados, *Ray Gun* attracted a growing audience weaned on MTV and other high-intensity graphic media. Carson mainstreamed the rule-busting postmodern tropes and developed a visual code for the youth market (as the psychedelic poster artists did for sixties youth culture). His method was definitely of its time because he marshaled the numerous quirks of the computer (and particularly QuarkXPress) in layouts that appeared to be computer mistakes. Instead, Carson deliberately exploited the worst case computer mishaps in layouts that, for example, had inconsistent column widths; reduced spacing between letters and words until the result was glob; used multiple type sizes in single words; cut type in pieces with rules; and overspaced words and letters. In addition, he made page numbers larger than headlines, ran entire stories backwards, and bled text off the page before the story ended. Carson was not just a maven for complexity, but reveled in incomprehensibility.

Yet illegibility did not prohibit Carson's style from achieving an immense following among students, young designers and commercial marketers. Even die-hard moderns such as Massimo Vignelli and Ivan Chermayeff have praised Carson as a "painter with type." Although they admit that his methods are inappropriate for certain audiences, they marvel at his facility to enliven a page (and perhaps go

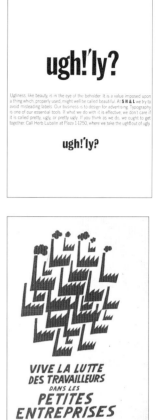

**Ugh!'ly?**
Advertisement, 1959

**Petite Entreprises**
Political poster, 1959
Designer: Attelier Populare

further than they would ever go themselves). Carson certainly inspired many younger designers to follow his lead and, therefore, a significant amount of fashionable graphic design from the early- to mid-nineties is an homage to his efforts. Yet these neophytes who mimic Carson (and what Carson represents) doubtless have no idea that what they are now doing began as a philosophical and aesthetic reaction to "less is more."

### Simplicity Redux

Impressionable (and that is most of us) people follow their heroes up the pop charts, and this is true with graphic design. When "less is more" was an ideology, the majority of untutored acolytes took the surface and made it into a style. When "more is more" was a valid response to too much austerity, the thoughtless followers made it into a trend. It is axiomatic that when a trend becomes overused it is ultimately rejected by the "alpha" group, who ride the crest of fashion, while it is continued by the retinue of followers until a new fashion establishes itself. This accounts for the return of simplicity to graphic design.

After radical change became the accepted norm, veteran designers have begun to question their motives and younger designers are reflexively rejecting the status quo. Retro is, however, only one aspect of a tidal shift. With the exception of the few who make pastiche, contemporary designers will practice in a manner consistent with their times. Charles Spencer Anderson borrowed the tropes of a bygone age, but interpreted them so that they represent his age. Likewise, designers returning to simplicity are not exactly aping the twenties Bauhaus, fifties Swiss modern, or the sixties creative revolution, but rather blending influences into a contemporary design idiom. That this idiom is a return to "less is more" is indeed a fact, but classical or late modernism, while an inspiration, is not the result. This book is a compendium of veteran designers who have returned to or have never rejected simplicity, as well as those neophytes for whom less was initially the better alternative.

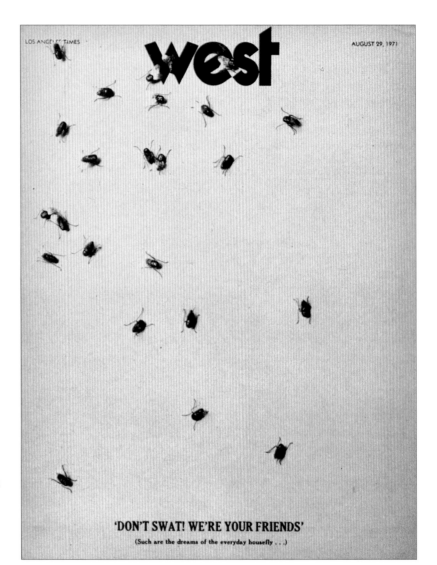

'DON'T SWAT! WE'RE YOUR FRIENDS'
(Such are the dreams of the everyday housefly . . .)

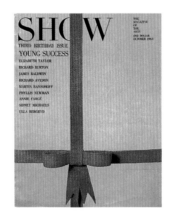

*West*
Magazine cover, 1971
Designer: Mike Salisbury

*Show*
Magazine cover, 1964
Designer: Henry Wolf

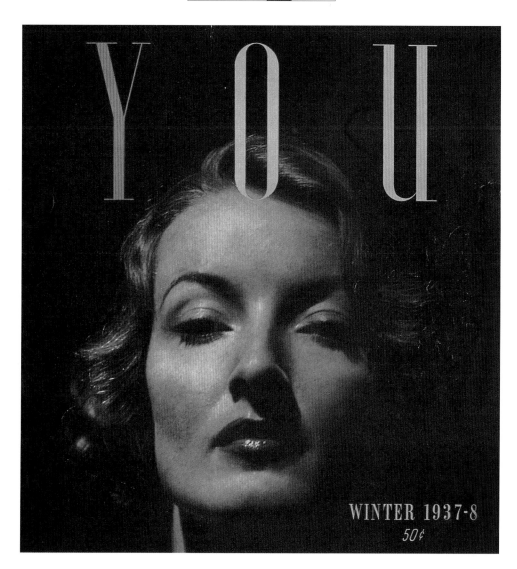

**Fact**
Magazine cover, 1966
Designer: Herb Lubalin

**CA**
Magazine cover, 1968
Designer: Richard Coyne

**YOU**
Magazine cover, 1937-1938

# The New Simplicity

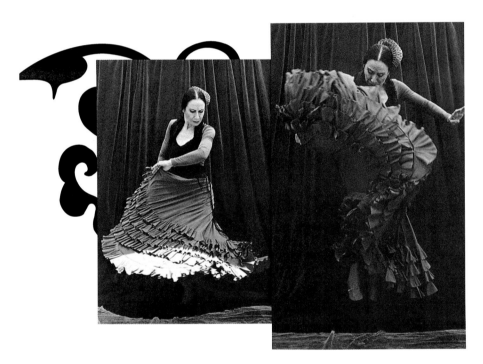

*Dance Ink*
Vol. 6, No. 4 (detail)
Photographer: K.C. Bailey

To what do we owe this return to simplicity? A variety of intersecting factors emerge: fashionable preferences, financial requirements, rejection of the status quo, and the pure pleasure of minimalism. "Less is more" is partly a trend, but more likely a response to the clutter that envelopes mass media. Making complex design is no longer as effective as it was when everything was more or less simple; in fact, it is not as much fun to make things reflexively complex. The examples in this section are not evidence of a definitive shift, but they are certainly evidence that alternatives are being explored and stylistic pluralism is flourishing.

# Advertising

'NICE ALTOIDS'

THE CURIOUSLY STRONG MINTS™

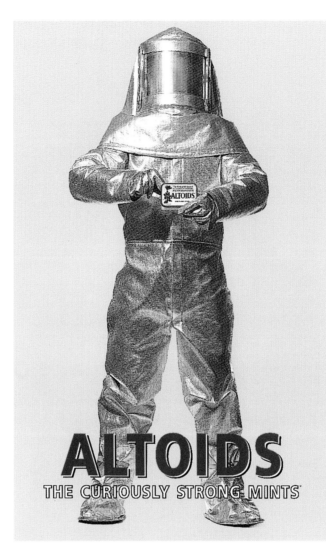

**Muscle Man, Silver Suit**
Design Firm: Leo Burnett USA
Art Director: Mark Faulkner
Photographer: Tony D'Orio
Client: Altoids

Before the turn of the century advertisements were conceptually and visually simplistic. A bold title announced the product being advertised. There were no creative admen pitching ideas, just printers and layout persons selling wares in the most straightforward manner. As consumer culture grew around the turn of the century, advertising messages pitched with more visual fervor and more copy. Ads were anything but simple—the more hype the better. Even the average posters were comparatively cluttered. Ultimately, advertisements (though set apart from editorial by decorative bor-

ders and other visual devices) required more reading time than the magazine or newspapers in which they appeared, prompting a reevaluation of overall effectiveness. In the United States, a few intrepid advertising people realized the virtue of balancing type and image (with emphasis on the latter), and others went a step further, reducing the clutter by introducing white space. In Europe, proponents of the new typography stripped ads of unnecessary ornament. By the late thirties advertising demanded dynamic layouts with a bullseye focal point. In the fifties the "creative revolutionaries," who introduced the "big idea," relied heavily on a strong headline and smart image to convey a memorable message. In the eighties and nineties, advertising design took two routes: deliberate clutter and stark simplicity. The former exploits the typographic trend for distorted and distressed typography and layered imagery (most often used to sell products and images to the young); the latter uses a discrete logo or headline with a single photograph, which, as the saying goes, speaks louder than a thousand words. As magazine designers are influenced more by advertising techniques, simplicity is a way to stand out and ensure memorability.

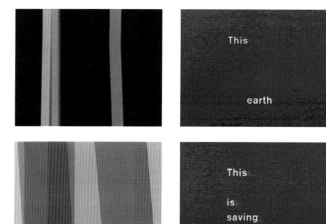

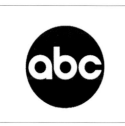

**ABC Daytime**
Design Firm: Number Seventeen
Art Directors: Emily Oberman,
Bonnie Siegler
Designer: Matthew Jacobsen
Client: American Broadcasting Co.

*Saturday Night Live* **Opening Sequence
1997**
Design Firm: Number Seventeen
Art Directors: Emily Oberman,
Bonnie Siegler
Client: National Broadcasting Co.

**Earth Share**
Design Firm: M&Co.
Art Directors: Tibor Kalman, Emily Oberman
Designer: Emily Oberman
Client: Earthshare

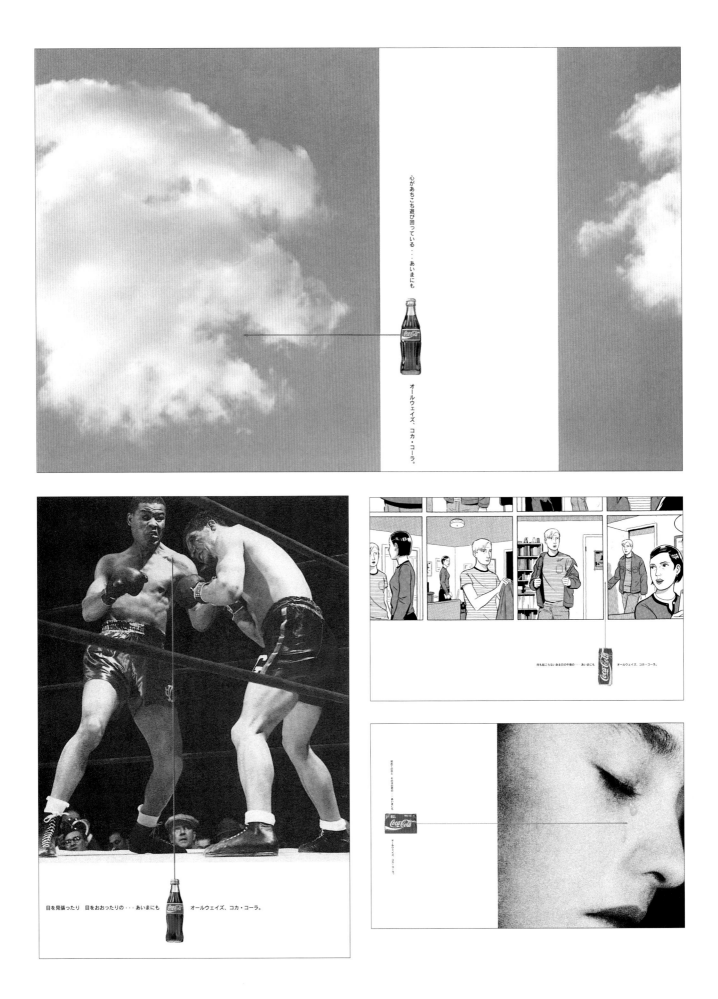

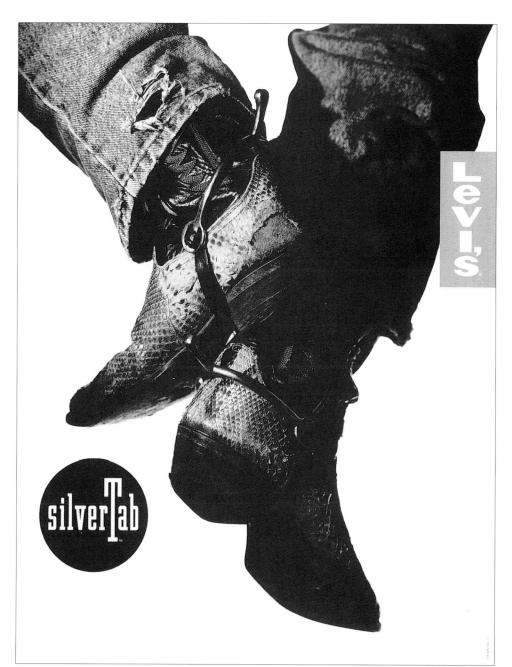

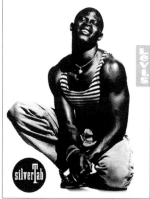

**Levi's Silvertab (boots, man)**
Design Firm: Michael Mabry Design
Art Directors: Aubyn Gwinn,
Michael Mabry
Designers: Michael Mabry, Margie Chu
Photographer: Albert Watson
Client: Levi-Strauss & Co.

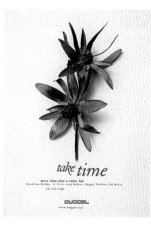

**Take Time**
Design Firm: Socio X
Art Director: Bridget De Socio
Designer: Ninja von Oertzen
Photographer: Don Freeman
Client: Duggal

**Coca-Cola ads**
Design Firm: Open
Art Director/Designer: Scott Stowell
Writer: Kathy Hepinstall
Illustrator: Adrian Tomine
Client: Wieden & Kennedy
for Coca-Cola

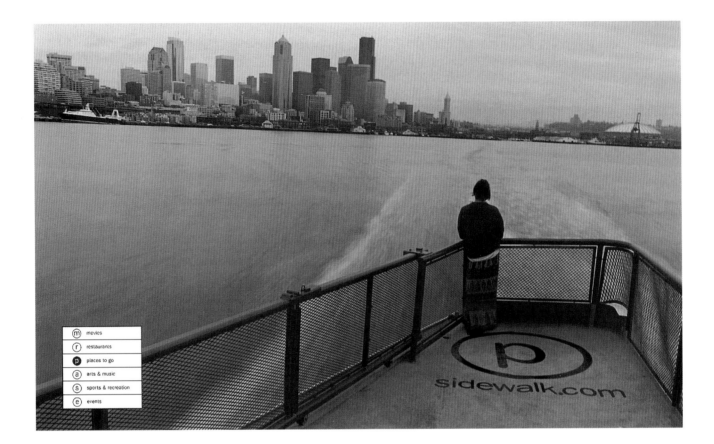

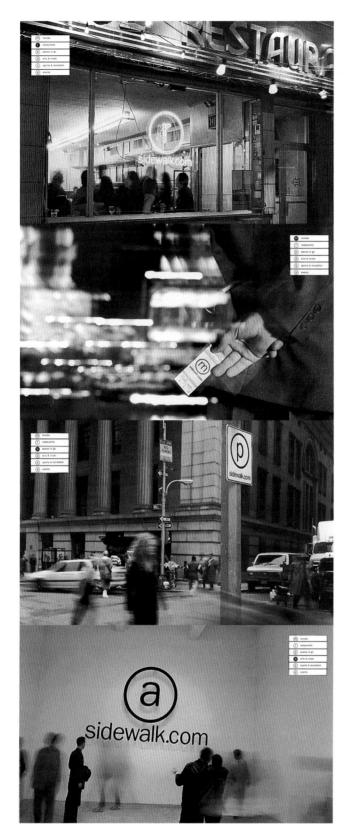

**sidewalk.com**
Design Firm: Wieden & Kennedy
Art Director: Chris Shipman
Writer: Scot Armstrong
Photographer: Richard Burbridge
Client: sidewalk.com

# Annual Reports

Annual reports have long been both a profit center and wellspring of creativity for graphic designers. Each year this genre has its share of innovative and inventive work. Yet the primary goal of a corporate annual report is not testing the limits of design experimentation, but rather conveying vital, often dry, business statistics to shareholders and other interested parties. While theoretically this can be accomplished in an economical way, in practice "good design," as Thomas Watson Jr. of IBM once pronounced, "is good business," and presenting this type of corporate data in a well conceived, executed, and produced form has been the norm for many decades. The average corporation expends huge budgets creating annual reports that frame their information with flair and style, and each year's crop runs the wide gamut from ostentatious to elegant. Nevertheless, a few reports inevitably appear without frills depending on the standing and confidence of the company. After a profitable year, a company may use lavish design to evoke their prosperity. After a poor year, a similar approach signals higher aspirations for the next. Inevitably, annual reports suggest boom rather than bust. But in recent years corporations have been more sensitive to issues of waste and some designers have attempted to bridge the divide between high production and restraint. Somewhere in between is not compromise so much as challenge to develop a corporate image that is self-confident in its identity and not reliant on the established clichés. The bull market style of glossy annual report from the early eighties has given way to a "less is more" mentality in the late nineties. Some of the best examples of reports shown here are reduced to accessible concepts, complimented by stylish, though functional, typography. Reduction does not mean it must be unappealing, either. Many of these reports are more surprising than those where gloss blinds the eye.

**Musicland Stores**
Design Firm: Werner Design Werks, Inc.
Designers: Sharon Werner, Amy Quinlivan
Client: Musicland Stores Corp.

All together now!

# iT'S
## Not Just
### ROCK AND
ROLL

" Musicland isn't *just* rock 'n' roll anymore. Actually, it never was. Growing up in the glory years of Ella Fitzgerald, Elvis Presley, and the Beatles, **Musicland Stores Corporation** made its reputation by offering audiophiles the widest selection of prerecorded music available anywhere. Nearly 40 years later, many of the big names have changed – Nirvana, Whitney Houston, Garth **MUSICLAND STORES** Brooks – but we're still a leader in the sale of prerecorded music products. We've also become a fast-growing force in "full-media" retailing. Today's Musicland Stores Corporation is music *plus* video *plus* books *plus* computer software.

In 1993 we continued to build the company on the solid foundation of our mall-based music and video businesses. We achieved significant growth with the addition of 12 full-media **Media Play** superstores in non-mall locations in major and mid-size metropol-

itan areas and with 19 smaller full-media **On Cue** stores in smaller markets. We increased our overall retail square footage by 1.1 million, expanded into new geographic areas, and broadened our product line. The Company solidified its financial position with a **CORPORATION** successful public stock offering that increased equity by $70.7 million and by retiring our high-cost debt through an offering of new debt at lower interest rates. We not only had a solid year in 1993, but also entered 1994 ready to make the most of the hottest retailing trends in the home-entertainment industry. **1993 ANNUAL REPORT**

For the year ended December 31, 1993, Company sales rose to $1.18 billion, an increase of 15.8 percent over

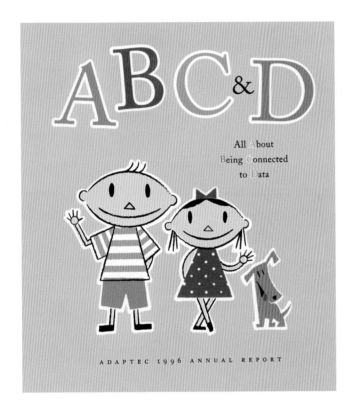

## Financial Contents

Results of Operations ................................................. 30
Management's Discussion and Analysis ....................... 31
Consolidated Statements of Operations ........................ 36
Consolidated Balance Sheets ...................................... 37
Consolidated Statements of Cash Flows ....................... 38
Consolidated Statements of Shareholders' Equity ...... 39
Notes to Consolidated Financial Statements .............. 40
Report of Management ................................................ 50
Report of Independent Accountants .......................... 51
Selected Financial Data ............................................. 52
Corporate Information ............................................... 53
Adaptec in the Community ........................................ 54

**A B C & D: All About Being Connected**
Design Firm: Cahan & Associates
Designer: Kevin Roberson
Client: Adaptec, Inc.

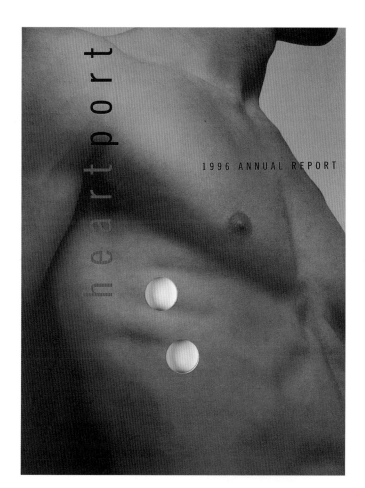

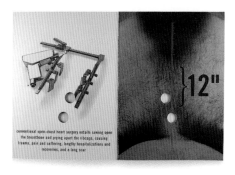

**Heartport 1996**
Design Firm: Cahan & Associates
Designer: Craig Bailey
Client: Heartport, Inc.

**A straight talk, no nonsensebook...**
**Lincoln National Corporation 1996**
Design Firm: SamataMason
Art Director: Greg Samata
Designers: Greg Samata, Erik Cox
Photographer: Sandro Miller
Client: Lincoln National Corporation

TO OUR STOCKHOLDERS: OAK TECHNOLOGY ACHIEVED SEVERAL IMPORTANT MILESTONES IN FISCAL 1995, CLEARLY THE BEST YEAR IN OUR COMPANY'S HISTORY: REVENUES EXCEEDED $100 MILLION FOR THE FIRST TIME. TOTAL SALES OF OUR CD-ROM CONTROLLERS TOPPED 10 MILLION DURING THE YEAR. OAK IS CURRENTLY THE WORLD'S LARGEST MERCHANT SUPPLIER OF CD-ROM CONTROLLERS. OAK BECAME A PUBLIC COMPANY IN FEBRUARY, AND RAISED ADDITIONAL CAPITAL WITH A FOLLOW-ON OFFERING IN MAY. WE COMPLETED OUR FIRST GUARANTEED CAPACITY AGREEMENT WITH A KEY SEMICONDUCTOR FOUNDRY AND ARE PURSUING ADDITIONAL ARRANGEMENTS.

**Admit One**
**Oak Technology 1995**
Design Firm: Cahan & Associates
Designer: Craig Clark
Client: Oak Technology, Inc.

**FEELS DIFFERENT,
DOESN'T IT?**

**Feels Different, Doesn't It?**
**Cadence 1996**
Design Firm: Cahan & Associates
Designer: Bob Dinetz
Client: The Cadence Design Systems, Inc.

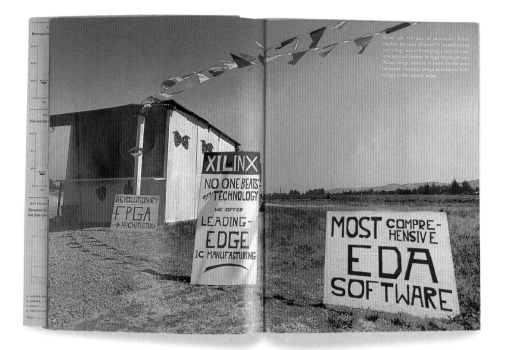

**Xilinx 1996**
Design Firm: Cahan & Associates
Designer: Kevin Roberson
Client: Xilinx, Inc.

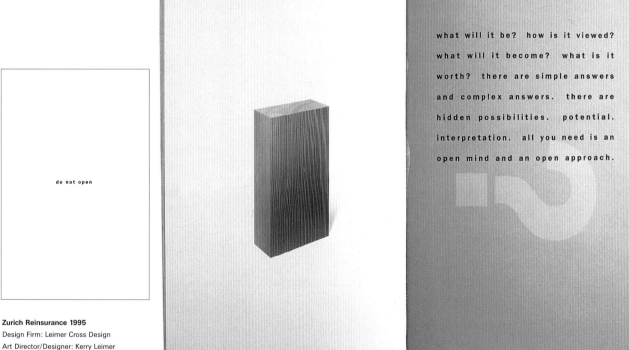

what will it be? how is it viewed? what will it become? what is it worth? there are simple answers and complex answers. there are hidden possibilities. potential. interpretation. all you need is an open mind and an open approach.

do not open

**Zurich Reinsurance 1995**
Design Firm: Leimer Cross Design
Art Director/Designer: Kerry Leimer
Client: Zurich Reinsurance Centre
Holdings, Inc.

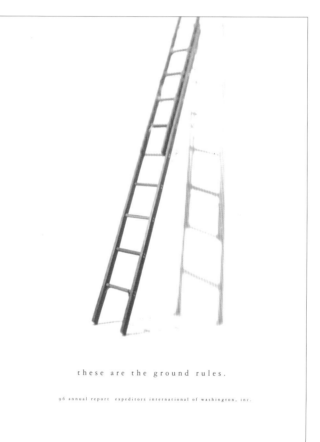

COR Therapeutics, Inc. 1996
Design Firm: Cahan & Associates
Designer: Kevin Roberson
Client: COR Therapeutics, Inc.

Expeditors International of
Washington, 1996
Design Firm: Leimer Cross Design
Art Director: Kerry Leimer
Designers: Kerry Leimer, Marianne Li
Client: Expeditors International of
Washington, Inc.

**Growth With Partners 1996**
Design Firm: Tolleson Design
Art Director: Steve Tolleson
Designers: Steve Tolleson, Jean Orlebeke
Illustrators: Stan Fellows, Jack Molloy
Client: GATX Capital Corporation

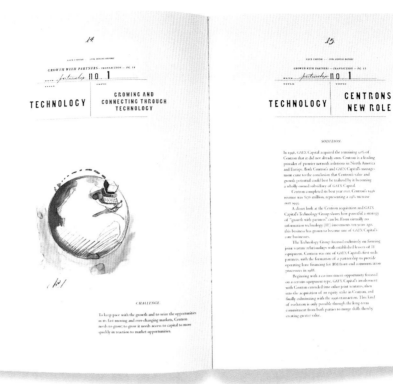

Penwest Pharmaceuticals Group is becoming an increasingly important part of our business. It combines the resources of Mendell, one of the world's leading producers and distributors of pharmaceutical excipients, with TIMERx, a technology platform of controlled release drug delivery systems for orally administered prescriptions and over-the-counter drugs. Mendell introduced seven new products based on our microcrystalline cellulose technology and offers the industry's widest array of excipients – the inactive ingredients in tablet and capsule formulations, over-the-counter drugs and vitamins. Mendell does business worldwide with primary markets in North America and Europe. Penwest Pharmaceuticals Group developed TIMERx, a patented, innovative controlled release technology.

**Penwest 1996**
Design Firm: Leimer Cross Design
Art Director/Designer: Kerry Leimer
Client: Penwest, Ltd.

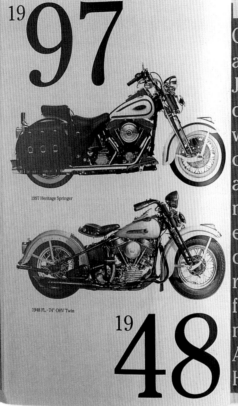

**HARLEY-DAVIDSON, INC.**
**1996 ANNUAL REPORT**

HERITAGE
QUALITY
PASSION
LOOK
SOUND
FEEL
RELATIONSHIPS
FREEDOM
INDIVIDUALITY
LIFESTYLE

19**97**

1997 Heritage Springer

1948 FL - 74" OHV Twin

19**48**

**HERITAGE**
Can history be a corporate asset? Just ask our customers, dealers and employees, who treasure our colorful past, glorious achievements and mystique. That's why every motorcycle we design and build pays rightful homage to its forebears. It's not just nostalgia; it's heritage. And it's unique to Harley-Davidson.

**Harley-Davidson 1996**
Design Firm: VSA Partners
Art Direction: Dana Arnett
Designers: Ken Fox, Fletcher Martin
Photographer: James Schnepf
Cover Artist: Scott Piper
Client: Harley-Davidson, Inc.

# Book Covers and Jackets

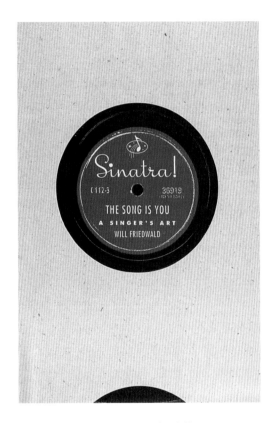

*Sinatra–the Song Is You*
Design Firm: Carin Goldberg Design
Designer: Carin Goldberg
Publisher: Scribner

The first book jacket, introduced in 1833 by English publisher Longman's & Co., was definitely less. In fact, it was little more than an unmarked piece of wrapping paper (hence the term "dust wrapper") that covered the entire book, protecting it from the elements. The jacket slowly evolved into what it is today, including flaps and a small window that revealed the title and author of the book, but was almost entirely void of design until the late nineteenth century, when type and decorative imagery were introduced. The book jacket and paperback cover ultimately became prime advertising surfaces, means to attract the browser's eyes and impart information about a book. Although design styles have changed, the medium is still governed by strict rules. The most significant is the rule that says a title and/or author's name must be visible from five feet away, which is religiously followed by designers of best-sellers where the hook is an author's brand name. Five-foot visibility on such a small format as a book makes simplicity a given. Yet during the years when complex layering reigned in many areas of graphic design, jackets and covers were also cluttered with fragments of type, photographs and other collaged or montaged imagery. Nevertheless, marketplace is an effective proving ground; while some degree of complexity may stimulate interest, on the whole bookstore shelves are already blasted with visual noise. Hence the simpler the composition the more seductive the result, or so the theory goes. In designing book jackets and covers getting the optimum benefit from "less is more" is really a balancing act of grabbing the reader's attention as a poster has to do, while conveying the provocative codes and cues with clarity and efficiency.

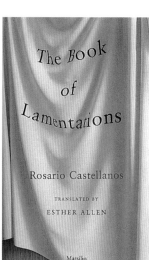

**The Book of Lamentations**
Design Firm: Doyle Partners
Designer: Stephen Doyle
Publisher: Marsilio

# Who Will Run the Frog Hospital?

## a novel by Lorrie Moore

**Who Will Run the Frog Hospital?**
Art Director: Carol Devine Carson
Designer: Barbara A. de Wilde
Publisher: Alfred A. Knopf

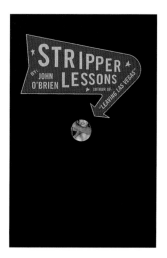

**Stripper Lessons**
Creative Director: John Gall
Design Firm: Office of Paul Sahre
Designer: Paul Sahre
Publisher: Grove Press

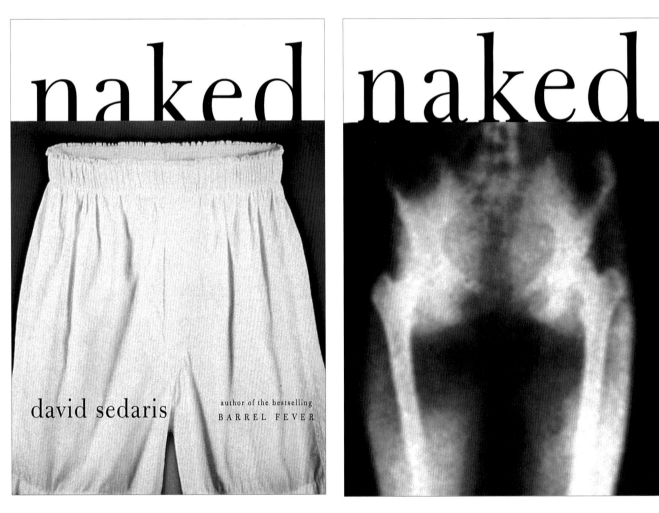

*Naked*
Designer: Chip Kidd
Publisher: Little, Brown

*The God of Small Things*
Art Director: Robbin Schiff
Designer: Gabrielle Bordwin
Photographer: Sanjeev Saith
Publisher: Random House

*Wormholes*
Design Firm: Carin Goldberg Design
Designer: Carin Goldberg
Publisher: Little, Brown

*The Untouchable*
Art Director/Designer: Carol Devine Carson
Publisher: Alfred A. Knopf

*Mother Said*
Design Firm: Carin Goldberg Design
Designer: Carin Goldberg
Publisher: Crown

*Stories in the Worst Way*
Designer: Archie Ferguson
Photographer: Nola López
Publisher: Alfred A. Knopf

*Objects*
Design Firm: Doyle Partners
Designer: Stephen Doyle
Publisher: Marsilio

*The Undertaking*
Art Director: Calvin Chu
Designer/Photographer: Barbara A. de Wilde
Publisher: W.W. Norton

*The Kiss*
Art Director: Andrew Carpenter
Designer: Patti Ratchford
Publisher: Random House

*The Fight*
Art Director/Designer: John Gall
Photographer: Thomas Hoepker/
Magnum Photo
Publisher: Vintage Books

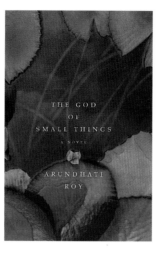

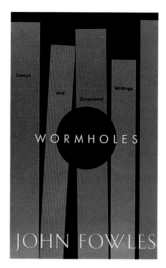

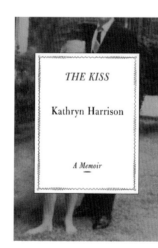

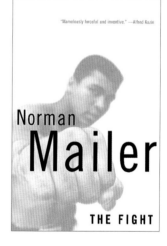

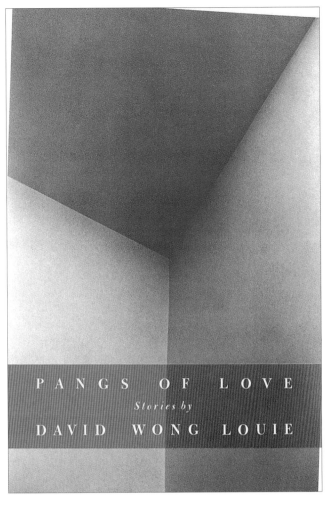

**Pangs of Love**
Art Director: Carol Devine Carson
Designer: Barbara A. de Wilde
Publisher: Alfred A. Knopf

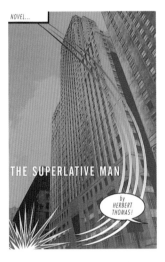

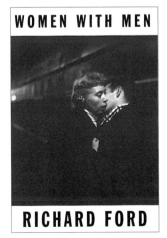

**Reason and Emotion in Psychotherapy**
Design Firm: Pentagram Design
Art Director: Michael Bierut
Designers: Michael Bierut, Emily Hayes
Publisher: Birch Lane Press

**The Superlative Man**
Design Firm: FSG Design Works
Art Director/Designer: Susan L. Mitchell
Illustrator: Chip Wass
Publisher: Farrar, Straus & Giroux

**Women With Men**
Art Director: Carol Devine Carson
Designer: Carol Devine Carson
Photographer: Ernst Haas/Magnum Photos
Publisher: Alfred A.Knopf

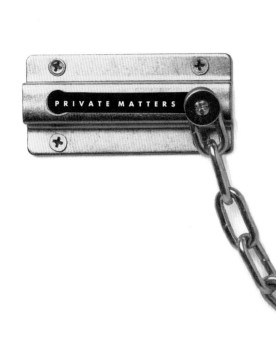

**Private Matters**
Art Director: Jean Seal
Designer: Leslie Goldman
Digital Art: Leslie Goldman
Publisher: Addison-Wesley

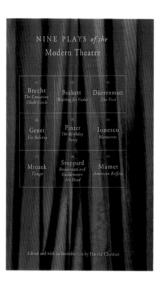

**Nine Plays of the Modern Theatre**
Design Firm: Office of Paul Sahre
Creative Director: John Gall
Designer: Paul Sahre
Photographer: Michael Northrup
Publisher: Grove Press

**Striving Towards Being**
Art Director: Michael Ian Kaye
Designer: Barbara A. de Wilde
Publisher: Farrar, Straus & Giroux

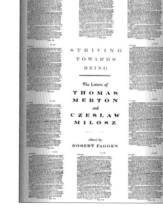

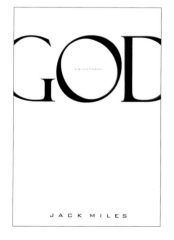

**God**
Design Firm: Pentagram Design
Designer: Michael Bierut
Publisher: Alfred A. Knopf

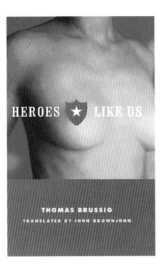

**Heroes Like Us**
Designer: Rodrigo Corral
Photographer: Diane Vasil
Publisher: Farrar, Straus & Giroux

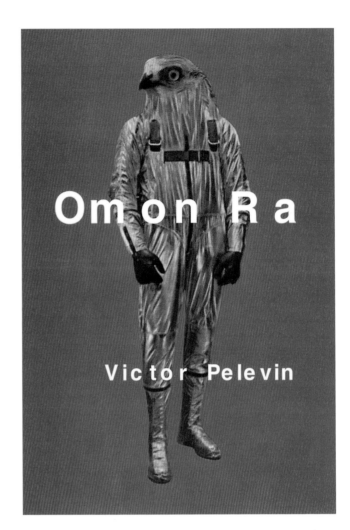

**Omon Ra**
Design Firm: Office of Paul Sahre
Creative Director: Michael Ian Kaye
Designer: Paul Sahre
Publisher: Farrar, Straus & Giroux

**Series for Marsilio Publishers**
Design Firm: Louise Fili Ltd.
Art Director/Designer: Louise Fili
Publisher: Marsilio

50

*Dance*
Design Firm: Delessert & Marshall
Designer: Rita Marshall
Illustrator: Etienne Delessert
Publisher: Creative Editions

*Dad Says He Saw You at the Mall*
Designer: Archie Ferguson
Publisher: Alfred A. Knopf

**Series for Bollati Boringhieri, Publisher**
Design Firm: Louise Fili, Ltd.
Art Director/Designer: Louise Fili
Publisher: Bollati Boringhieri

*Dr. Seuss & Mr. Geisel*
Designer: Andrew Carpenter
Publisher: Random House

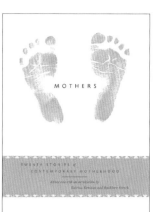

*Mothers*
Art Director: Michael Ian Kaye
Designer: Leslie Goldman
Publisher: Farrar, Straus & Giroux

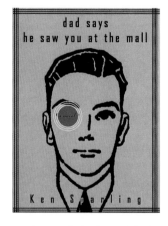

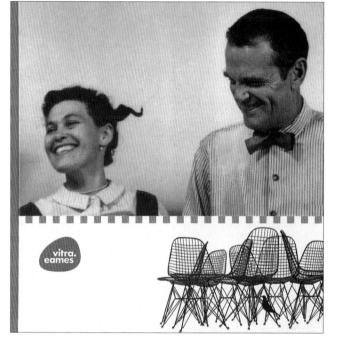

**Eames|Vitra**
Design Firm: Design/Writing/Research
Art Director: J. Abbott Miller
Designers: J. Abbott Miller, Luke Hayman,
Paul Carlos
Publisher: Vitra

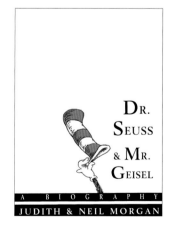

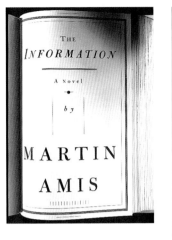

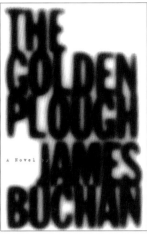

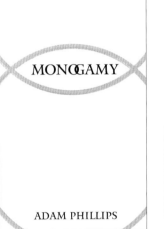

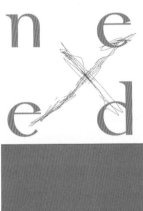

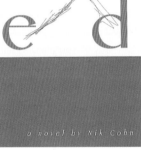

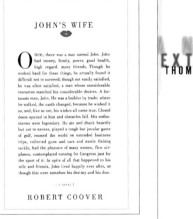

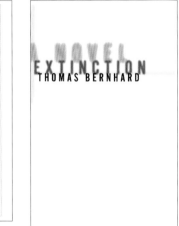

**The Information**
Designer/Photographer: Chip Kidd
Publisher: Harmony

**The Golden Plough**
Art Director: Michael Ian Kaye
Designer: James Victore
Publisher: Farrar, Straus & Giroux

**Monogamy**
Art Director: Marjorie Anderson
Designer: Kathleen DiGrado
Publisher: Pantheon Books

**Need**
Art Director: Carol Devine Carson
Designer: Barbara A. de Wilde
Publisher: Alfred A. Knopf

**John's Wife**
Design Firm: Carin Goldberg Desing
Designer: Carin Goldberg
Publisher: Simon & Schuster

**Extinction**
Designer: Chip Kidd
Publisher: Alfred A. Knopf

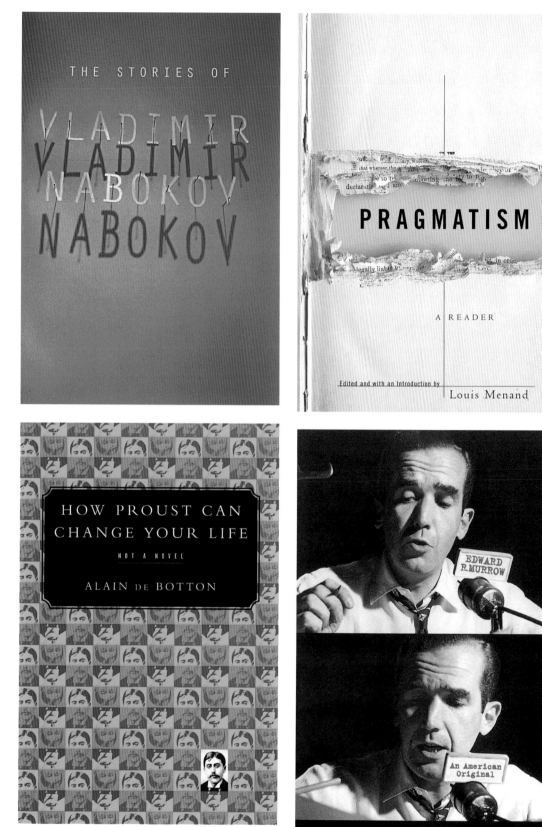

**The Stories of Vladimir Nabokov**
Design Firm: Doyle Partners
Designer: Stephen Doyle
Publisher: Alfred A. Knopf

**How Proust Can Change Your Life**
Art Director: Marjorie Anderson
Designer: Kathleen DiGrado
Photography: The Granger Collection, NY
Publisher: Pantheon Books

**Pragmatism**
Art Director: John Gall
Designer: John Gall
Photographer: Katherine McGlynn
Publisher: Vintage Books

**Edward R. Murrow: An American Original**
Design Firm: Steven Brower Design
Designer: Steven Brower
Photographer: Photofest
Publisher: Da Capo Press

# Books

In 1951 the American Institute of Graphic Arts mounted "Books for Our Time," an exhibition that explored the nature of modern design in the book industry. For centuries book design had been governed by traditional principles of central axis layout, but by the fifties young designers rejected the tried and true methods for new notions of dynamic asymmetry influenced by the Bauhaus and de Stijl.

Although the overall look of books changed, nevertheless both old and new had something fundamentally in common: readability born of simplicity. Most book design, whether classical, modern or postmodern, requires a modicum of order; and order (the absence of clutter) involves reduction (if not total rejection) of gratuitous decoration. Book design may include many different components—running heads and feet, chapter and subtitles, page numbers, initial caps—but these must be harmonious and function as a whole. The book, therefore, is graphic design complexity functioning through simplicity. It is the marriage of various and diverse components in the service of meaning and understanding. And at the same time each book is an individual entity with a look, feel and character all its own. Book pages can be resolutely reductive or

demonstrably layered, but in the end the navigability of a book must efficiently deposit the reader at a clearly defined destination. Book designers who practice the precept of "less is more" do not necessarily reduce the page to the most rudimentary elements—in fact, they use whatever they have to maximize the impact of the word or image. The most effective book designs are those where design is an unselfconscious framing of content rather than an attempt at a "work of art." The books exhibited in this section are not "artists' books." And while they represent a number of styles and mannerisms, they also exhibit the best tenets of simplicity in the service of aesthetics and utility.

*Fetish & Fame*
**Video Music Awards Program**
Art Directors/Designers: Jeffrey Keyton, Stacy Drummond, Tracy Boychuk
Publisher: MTV Off Air Creative

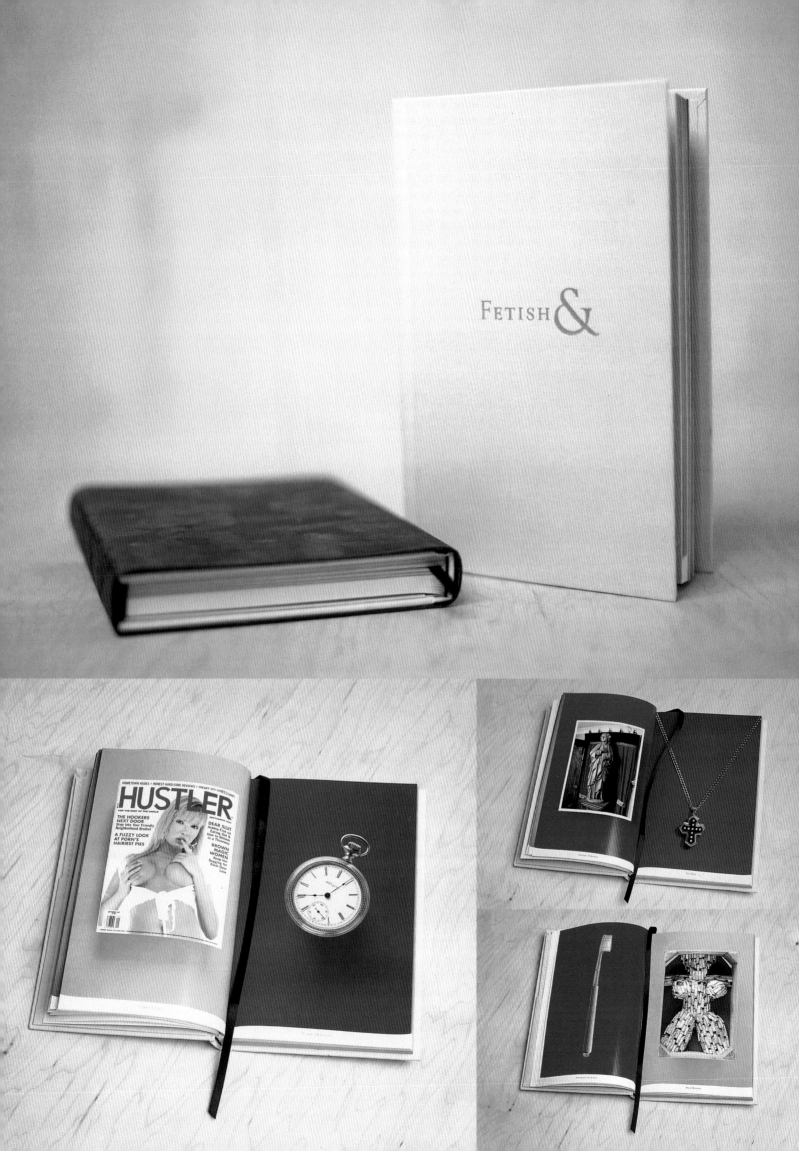

*Designer's One Liners*
Design Firm: M. Skjei Design Co.
Designer: M. Skjei
Publisher: M. Skjei

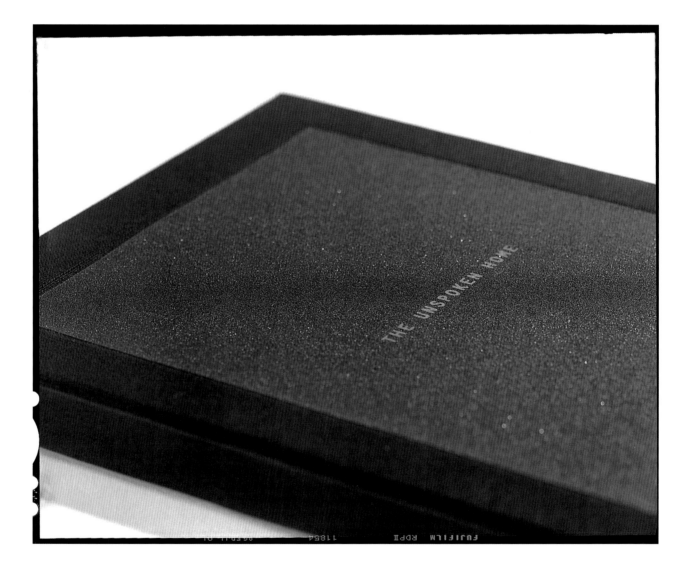

*The Unspoken Home*
Designer: Anne Fink
Photographer: Victor Schrager
Publisher: Anne Fink

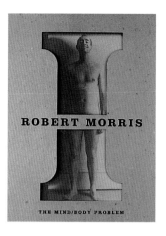

**ROBERT MORRIS**

THE MIND/BODY PROBLEM

## CARD FILE, 1962

The locus of the "Caucus-race," an absurdist game described in Lewis Carroll's *Alice in Wonderland* in which the players start and stop as they wish, move more slowly when trying to move more quickly, and mysteriously end up where they began, is that of systematized senselessness. It is this field that Morris entered from time to time in order to disrupt, or make self-conscious, the movement and process of generating a work of art. An example is the early neo-Dada *Card File* (1962, no. 26), a wall-mounted, vertical flat file containing a group of alphabetically indexed cards that record the steps the artist followed in conceiving of and making it. Like Carroll's players, the work is guided by an absurd logic of disclosure that, in explicating the supposedly hidden progression that leads from "creative" intention, to the act of composition, to the final art work itself, comments on and rethinks that process.

First shown in 1963 at the Green Gallery in New York, and subsequently in *Language*, a show at the Dwan Gallery in New York, *Card File* operates according to an internal system of cross-referencing that drives a step-by-step procedure for the viewer to follow. Traveling the circuitous route mapped by the cards, one moves, ironically, through the intentions and process by which the work was elaborated.

Archival orderliness—or so it seems until one notices the "mistakes" and lost cards—is the disguise that this work assumes in order to perform what is a fragmentary, non-narrative, and irreducibly complex process. The forty-four file cards, gathered under various subject headings—"Accidents," "Categories," "Decisions," "Forms," "Interruptions," "Losses," "Mistakes," "Owners," "Signature," and "Stores," among them—bear an assortment of typed remarks that indicate considerations and circumstances that figured in the work's making. Thus we read that Morris purchased the cards at Daniels Stationary [sic], lost them, recovered them, discussed the work with a friend, conceived the work in the New York Public Library, made mistakes, was interrupted by Ad Reinhardt, and so on.

In its obsessive autoreferentiality, *Card File* gives the lie to any notion of creative spontaneity, burlesquing the traditional idea of the art work as the sum of the intentions and actions of the artist.

**following three pages: 26. Card File,** 1962 (full view and six cards). Metal and plastic wall file mounted on wood, containing forty-four index cards, 27 x 10¹⁄₂ x 2 inches (68.6 x 26.7 x 5.1 cm). Musée National d'Art Moderne, Centre Georges Pompidou, Paris.

126 ROBERT MORRIS

CARD FILE 127

*Robert Morris: The Mind/Body Problem*
Design Firm: Design/Writing/Research
Designer: J. Abbott Miller
Design Assistant: David Williams
Publisher: The Solomon R. Guggenheim
Foundation

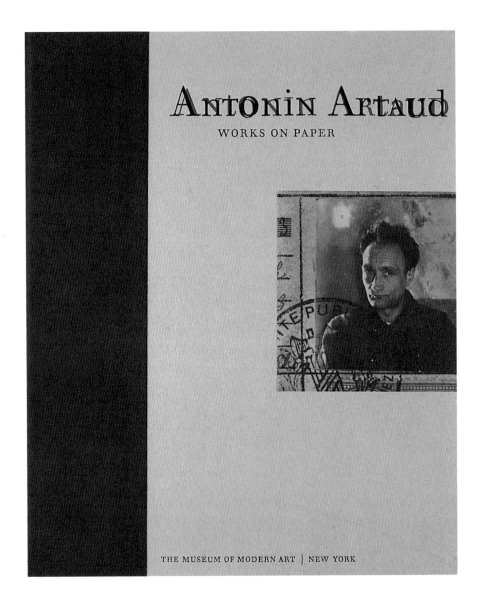

# ANTONIN ARTAUD

## WORKS ON PAPER

THE MUSEUM OF MODERN ART | NEW YORK

***Antonin Artaud: Works on Paper***
Design Firm: Design/Writing/Research
Designers: Paul Carlos, J. Abbott Miller
Client: The Museum of Modern Art, New York

59

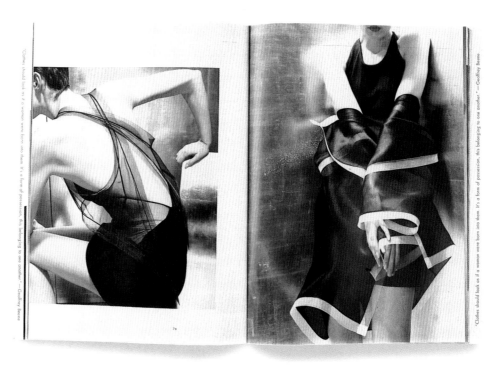

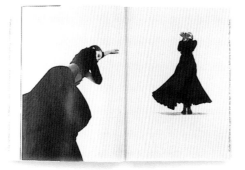

# Geoffrey Beene

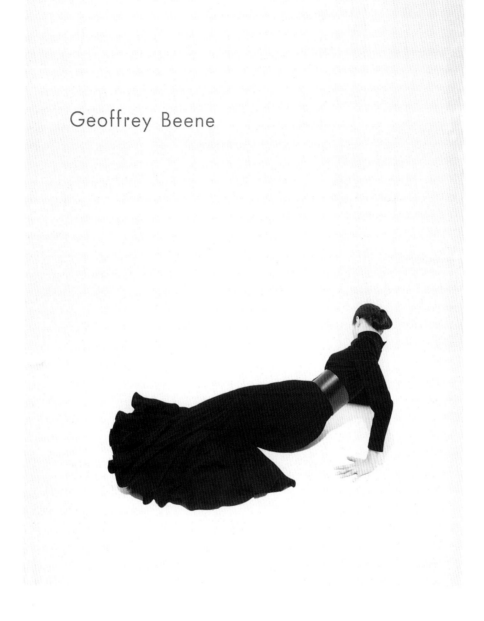

**Geoffrey Beene**
Design Firm: Design/Writing/Research
Art Director/Designer: J. Abbott Miller
Photographer: Andrew Eccles
Publisher: Harry N. Abrams

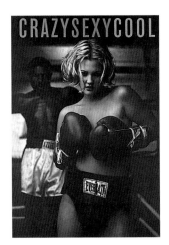

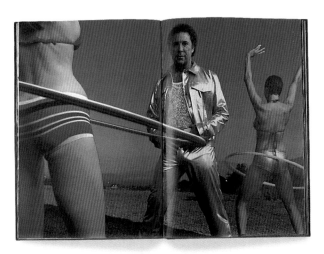

I THINK IN my singing I allow myself the luxury of vulnerability, which I don't really allow in my personal life. I think I'm just...very masked, I've got a poker face. But in singing you can't help exposing your vulnerability.

I HONESTLY DON'T give a fuck what anybody thinks about me – except the people close to me.

PLAY DISENFRANCHISED people that are in most cases pushed out of the way or cast aside. Part of my agenda with that is out of some kind of need to save them. To be representative of those people.

I GET TO BE A KID NOW, because I wasn't a kid when I was supposed to be one. But in some ways, I'm an old woman – lived it, seen it, done it, been there, have the T-shirt.

FOR A LONG TIME I FELT like an anarchist, wanting to destroy everything which seemed in the way. But that's a hard label to live up to. I don't want to be wild every day.

MY CHARACTERS ARE slightly damaged, slightly neurotic, but with an incredible determination and an undying spirit. No matter how battered and bruised they might become, they have this will to persevere.

OK, I'M 37. I'm not supposed to do certain things – speak up for myself, change my life. I'm too old. Well, FUCK THAT!

I BELIEVE IN the Wild Man. It's that instinctual, innate part of you, your power, that if used constructively can be an incredibly productive force. But off-kilter the least bit, it'll kill you. I'm real intrigued by that edge. It can create an unpredictable, dangerous performance. I want the Wild Man in my work.

EVERYBODY PUTS a label on it and calls me a bad boy or a delinquent or a rebel or one of those horrible terms. But to me, it was much more *curiosity*.

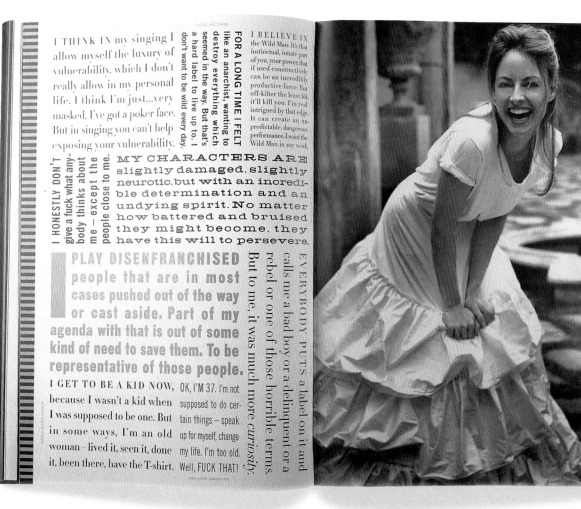

*CrazySexyCool*
Designer: Fred Woodward
Photographer: Mark Seliger
Publisher: Little, Brown

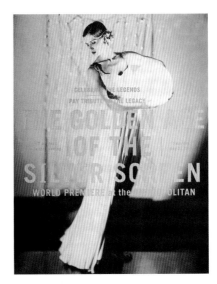

# Catalogs and Brochures

**The Golden Age of the Silver Screen**
Design Firm: Carmichael Lynch Thorburn
Designer: Chad Hagen
Photographer: Bill Phelps
Writer: Jonathan Sunshine
Client: Association for Children's
Healthcare of Minneapolis

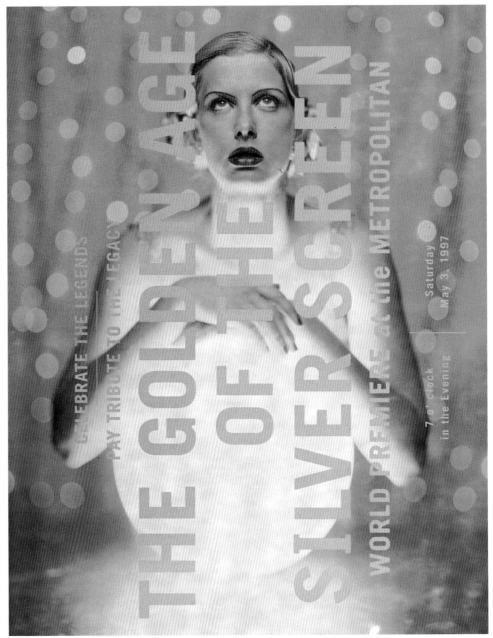

There is no logical reason why a catalog or brochure should not be clearly and cleanly designed. Although catalogs are expected to contain excessive amounts of information, and readers have accustomed themselves to navigating (or plowing) through the morass of data to locate what they need, too much time is invariably wasted trying to find items obscured by poor organizing principles. In the early fifties Ladislav Sutnar, a Czech-born graphic designer with roots in the European constructivist movement, forever changed the standard of catalog design when he totally overhauled the Sweets Catalog Service compendium of industrial parts and accessories catalogs. Simplification was the by-product of a unique design scheme that emphasized accessible grid systems rather than stuff-and-fit layouts. Using graphic icons as guideposts, he further developed methods for cross-referencing from one product to another so that the user could scan and select from sets of rational menus (prefiguring navigational principles on the World Wide Web). In a genre where "more" is the commonplace, "less" graphic detritus— including a reduction in the amount of typefaces, rules, pictures, etc.—enables the user to move quickly and freely between items. In recent years, with the increase of mail-order-based businesses, the catalog has become an important tool for consumers. It has, therefore, been a real challenge to design efficiently and pleasingly. The catalogs exhibited here represent a variety of industries, businesses and organizations (commercial and cultural). While none of them are the meat-and-potatoes reference guides and ordering books that Sutnar so brilliantly transformed, they are showcases for products and messages that nonetheless require clean and entertaining presentations. Simplicity is its own reward, for it encourages increased use. But "less is more" is not a common template. Every piece is simpli-

fied, reduced or economical according to the function for which it is needed. Not all catalogs or brochures can afford to be minimal to the zero degree, but the examples in this section use design sparingly and elegantly to convey large amounts of information. It may seem otherwise, but catalogs (and to a lesser extent brochures) are the hardest printed pieces to design simply.

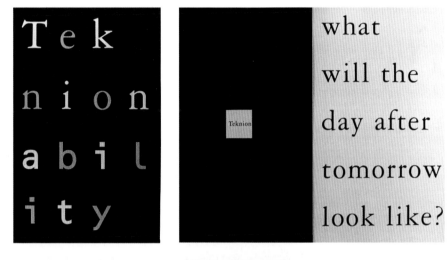

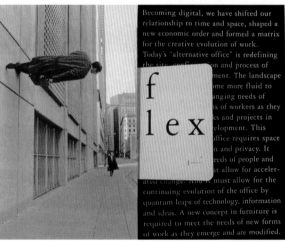

**Teknion**
Design Firm: Vanderbyl Design
Designer: Michael Vanderbyl
Photography: Geoff Kern
Client: Teknion

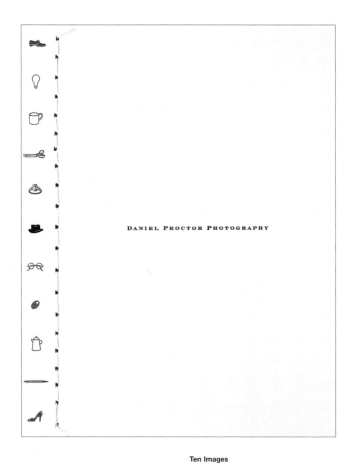

**Ten Images**
Design Firm: Michael Mabry Design
Art Director: Michael Mabry
Designers: Michael Mabry, Kristen Malan
Client: Daniel Proctor Photography

***Debrief*** newsletter
Design Firm: Free Associates
Art Director/Designer: G. K. Van Patter
Client: Center for Research in Applied Creativity

**Eight Days**
Design Firm: Michael Mabry Design
Art Director/Designer: Michael Mabry
Photographer: Michael Mabry
Client: Emily Mabry

**Back/Front**
Design Firm: Lippa Pearce
Art Director/Designer: Domenic Lippa
Concept and Copy: Jonathan Budds, Dick
Dunford, Indra Sinha
Client: Design and Art Directors Association

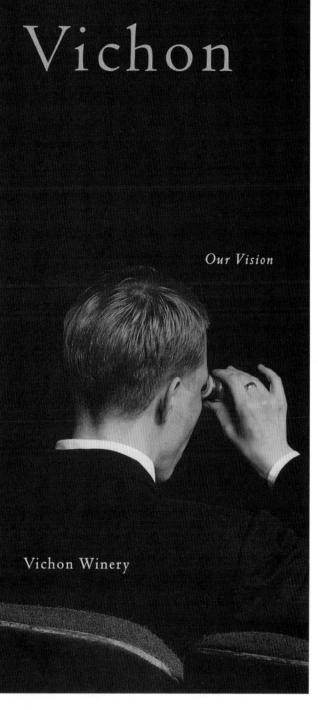

**Planet Design Company brochure**
Design Firm: Planet Design Company
Designer: Jamie Karlin
Client: Planet Design Company

**Passion**
Design Firm: Vanderbyl Design
Designer: Michael Vanderbyl
Photography: Jock McDonald
Client: California College of Arts and Crafts

**Vichon Winery brochure**
Design Firm: Cahan & Associates
Designer: Sharrie Brooks
Client: Vichon Winery

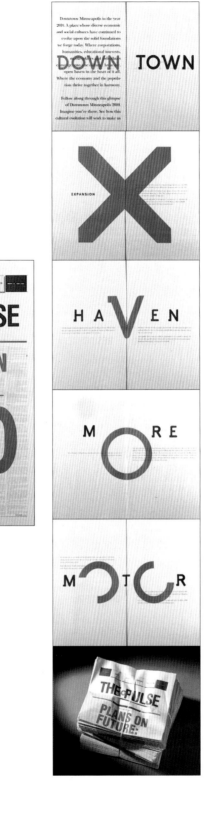

DOWN TOWN

X

EXPANSION

HA**V**EN

M**O**RE

M**⊃⊂**R

THE⊕PULSE
PLANS ON FUTURE:

THE⊕PULSE

PLANS ON
FUTURE:

DTWN2010

THE EXPANDED
CORPORATE
CULTURE FEEDS
SURROUNDING
RETAILERS A
STEADY DIET OF
HUNGRY CUS-
TOMERS.

WITH ITS UNIQUELY DYNAMIC,
SAFE AND VITAL ENVIRONMENT,
DOWNTOWN CREATES A HIGH
DEMAND FOR URBAN LIVING.
THE STREETS, PARKS AND
EDUCATIONAL OPPORTUNITIES
ARE ALL INCREDIBLY
INVITING.
ENTICING MORE AND MORE
PEOPLE TO CHOOSE DOWN-
TOWN AS THEIR

RESIDENCE.
WELCOME

BY CREATING
MANY EXCITING
NEW OPTIONS
FOR MOTORING
IN AND AROUND
OUR CITY SAFELY
AND EASILY,

**The Pulse**
Design Firm: Carmichael Lynch Thorburn
Designer: David Schrimpf
Photographer: Chuck Smith
Writer: Michael Cronin
Client: Minneapolis Downtown Council

**five decades**
Design Firm: Knoll Graphics
Designer: Coco Kim
Client: Knoll, Inc.

**SunDog Brochure**
Design Firm: Hornall Anderson
Design Works, Inc.
Art Director: Jack Anderson
Designers: Jack Anderson, David Bates
Client: SunDog, Inc.

**The VH1 Awards**
Design Firm: Werner Design Werks, Inc.
Designers: Sharon Werner, Amy Quinlivan
Client: VH1

**Mohawk 50/10 Plus: Mother Goose**
Design Firm: Werner Design Werks, Inc.
Art Director: Sharon Werner
Designers: Sharon Werner, Sarah Nelson
Photographer: Darrel Eager
Client: Mohawk Paper Mills, Inc.

**James H. Barry: 7 brochures**
Design Firm: Michael Mabry Design
Designer: Michael Mabry
Design: Michael Mabry, Margie Chu
Photographer: Michael Lamotte
Client: The James H. Barry Company

**redgroup**
Design Firm: Haley Johnson Design Co.
Designer: Haley Johnson
Client: redgroup

**Arkitektura**
Design Firm: Worksight
Designer: Scott W. Santoro
Client: Strathmore International Paper

**No Boundaries**
**1996–1997 Season brochure**
Design Firm: JNL Graphic Design
Art Director: Jason Pickleman
Designers: Jason Pickleman, Jason Feldman
Client: Performing Arts Chicago

forecast (front and back)
Design Firm: 2x4
Designer: Coco Kim
Client: Knoll, Inc.

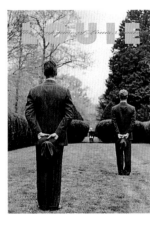
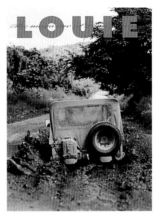
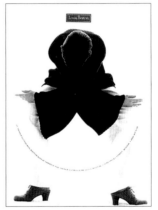

*Louis* magazine
Design Firm: Tyler Smith
Art Director/Designer: Tyler Smith
Fashion Photographer: Arnaldo Anaya-Lucca
Client: Louis, Boston

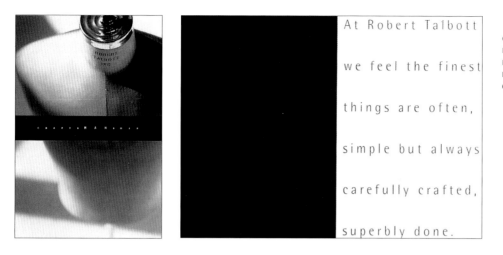

At Robert Talbott we feel the finest things are often, simple but always carefully crafted, superbly done.

**Craftsmanship**
Design Firm: Vanderbyl Design
Designer: Michael Vanderbyl
Photography: David Peterson
Client: Robert Talbott Inc.

**Strange But True**
Design Firm: Eric Baker Design Associates
Designer: Eric Baker
Assistant Designer: Greg Simpson
Client: Gilbert Paper

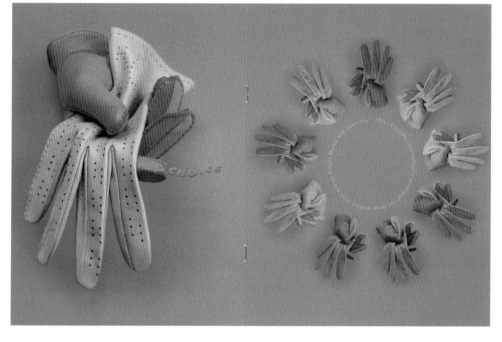

**Pantone**
Design Firm: Socio X
Art Director: Bridget De Socio
Designers: Jason Endres, Ninja von Oertzen
Photographer: Victor Schrager
Client: Pantone

THERE IS LIFE ON
ANOTHER PLANET:
1 IN 1,000,000,000

SLIM TO NONE

1st

SLIM TO NONE

CHANCES THAT
YOUR NEXT PRODUCT
WILL BE A WINNER:

1 IN 10,000

**Chances That There Is Life...**
Design Firm: Cahan & Associates
Designer: Bob Dinetz
Client: GVO, The Product Definition
& Development Company

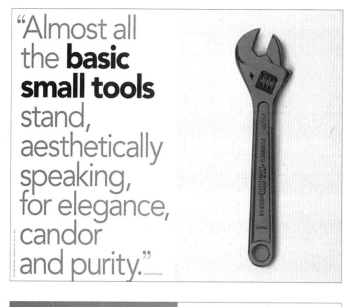

"Almost all the **basic small tools** stand, aesthetically speaking, for elegance, candor and purity."

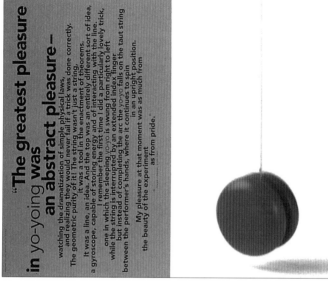

"The greatest pleasure in yo-yoing was an abstract pleasure—

watching the dramatization of simple physical laws, and realizing they would never fail if a trick was done correctly. The geometric purity of it! The string wasn't just a string, it was a line, an idea. And the top was an entirely different sort of idea, a gyroscope, capable of storing energy and of interacting with the line. I remember the first time I did a particularly lovely trick, one in which the sleeping yo-yo is swung from right to left while the string is interrupted by an extended index finger, but instead of completing the arc the yo-yo falls from the taut string between the performer's hands, where it continues to spin in an upright position. My pleasure at that moment was as much from the beauty of the experiment as from pride."

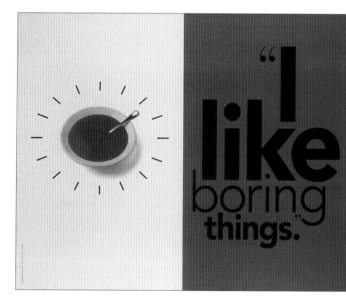

"I like boring things."

**Perfectly Ordinary**
Design Firm: Pentagram Design
Art Director : Michael Bierut
Designers: Michael Bierut, Lisa Cerveny
Client: Mohawk Paper Mills, Inc.

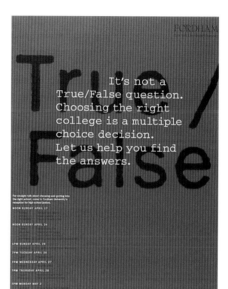

It's not a True/False question. Choosing the right college is a multiple choice decision. Let us help you find the answers.

**True/False**
Design Firm: Frankfurt Balkind Partners
Creative Director: Kent Hunter
Art Directors: Kent Hunter, Abbey Balkind
Designers: Robert Wong, Brett Gerstenblatt
Client: Fordham University

# Music

The earliest record packages were, like book jackets before them, purely utilitarian protective sleeves almost void of artistic embellishment, save for the record company's trademark. Albums were introduced in the twenties as a receptacle for longer music collections contained on the bulky, shellac 78rpm disks (playing time approximately four minutes per side). Modeled on the format of an old photo album, record album covers were kraft paper glued to boards, drab and colorless with only a title or recording artist's name embossed in gold leaf on the front and spine. Aptly referred to as "tombstones," albums typically sat lifeless on shelves, spines facing out.

In 1939 the first original color art was introduced to albums and sales soared (according to *Newsweek* magazine) by 800 percent. From then on album art was accepted as a key sales incentive, especially once the $33\frac{1}{3}$ rpm sleeve was developed. Styles changed, and what began as abstract illustration, in the Fifties became mood photography. The album cover was prime real estate for the creative designer. The "cool" look of such labels as Blue Note, Riverside and Decca introduced a late modern reductive sensibility to the genre. And over the years fashion turns have dictated the many different approaches from the psychedelic clutter to new age visual poetics. The biggest change to hit record albums in over forty years was reduction of a physical kind: a shift from LPs to CDs. Forget the fidelity of the music itself, the quality of the image demanded that designers not just think in terms of miniposters, but in miniproportions. Although not every contemporary album cover is minimally

designed, for a composition to efficiently evoke the allure or brand identity, "less is more" is a necessity. Today's record album design is not entirely different from the LP days, but it is generally more focused on a central image with clear type strategically composed. Contemporary albums in the reductive mode range in style from homages to the glory days of cool jazz to elegant classical simplicity.

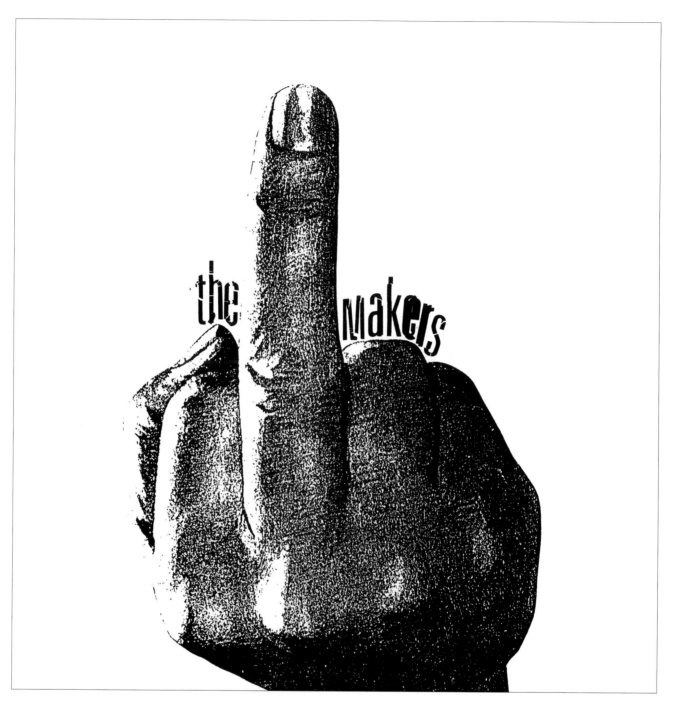

***The Makers*** (front and back)
Art Director/Designer: Art Chantry
Client: Estrus Records, Dave Crider

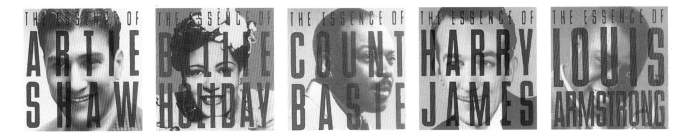

"Essence of Jazz" Series
Design Firm: Sony Music Creative Services
Art Director/Designer: Allen Weinberg
Designer: Allen Weinberg
Client: Sony Music Entertainment Inc.

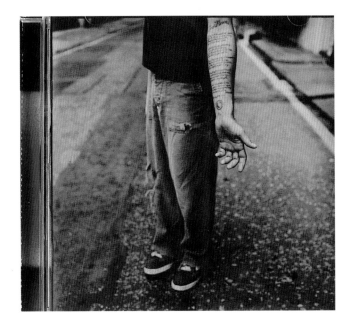

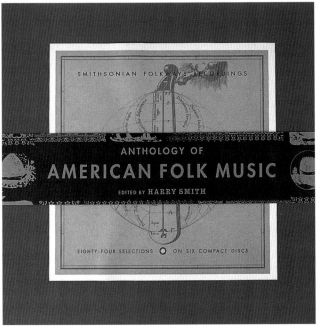

**Blind Melon:** *Nico*
Design Firm: Capitol Records Art
Art Directors: Jeffrey Fey, Tommy Steele
Designer: Jean Krikorian
Photographer: Danny Clinch
Client: Capitol Records

*Anthology of American Folk Music*
(box set and booklet)
Design Firm: Open
Designer: Scott Stowell
Client: Smithsonian Folkways Recordings

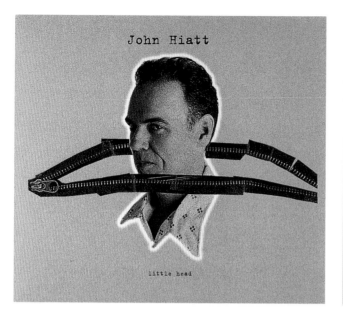

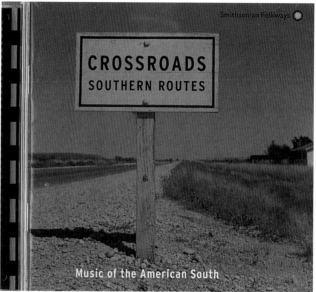

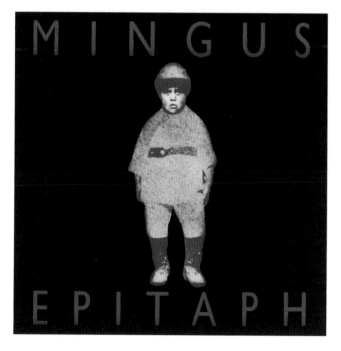

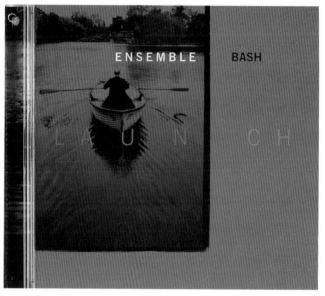

**John Hiatt:** *Little Head*
Design Firm: Capitol Records Art
Art Directors: Tommy Steele, Jeffrey Fey
Designer: Jeffrey Fey
Photographer: Neal Preston
Client: Capitol Records

**Mingus:** *Epitaph*
Design Firm: Sony Music Creative Services
Art Director: Allen Weinberg
Client: Sony Music Entertainment Inc.

*Crossroads: Southern Routes*
Design Firm: Open
Designer: Scott Stowell
Client: Smithsonian Folkways Recordings

**Ensemble BASH: LAUNCH**
Design Firm: Sony Music Creative Services
Art Director/ Designer: Julian Peploe
Photographer: Richard Kalina
Client: Sony Classical

**The Inhalants**
Art Director/Designer: Art Chantry
Client: Estrus Records, Dave Crider

**Pigeonhed**
Front and back
Art Director/Designer: Art Chantry
Photographer: Arthur S. Aubry
Client: Sub Pop

**Jon Bon Jovi:** *Destination Anywhere*
Design Firm: Creative Services for
Mercury Records
Designer: Jeffrey Schulz
Client: Mercury Records

*Automation All Around*
Design Firm: Creative Services for
Mercury Records
Designer: Louis Marino
Client: Mercury Records

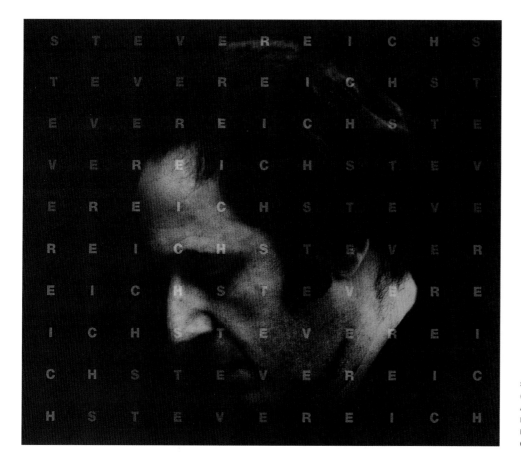

**Steve Reich Works**
(10 CDs & booklet)
Art Director: John Gall
Designers: John Gall, Judith Hudson
Photographer: Betty Freeman
Client: Nonesuch Records

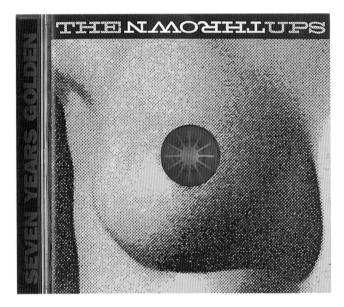

1. Your Band Sucks
2. She's Fat
3. Eat My Dump
4. Flubber Mate
5. Bucking Retards
6. Dude Pump
7. Person In My Bowel
   (Is Sad)
8. Fleshy Web Pit
9. Elephant Crack
10. My Cock Is The Coin
11. Hairy Crater Man
12. Sparse Tits
13. Smiling Panties
14. Be Correct
15. Melancholy Girlhole
16. Stock Boy, Superhero
17. Felch
18. Laid Butt
19. Sloppy Pud Love
20. Hot Lunch
21. The Ladies Love Me
22. Scabby Like My Love
23. My Love Is Simple
24. R Ladies R Bitches
25. Patty Has A Problem
26. Slick Lip
27. Thorp, Thorp

The Thrown Ups' music has much to teach us about ourselves and our world. Each successive listening brings forth new revelations...new facets of the enigma. Unsurpassed and still utterly without peer, The Thrown Ups' body of work stands up as well today as when it first was released. Some music is timeless.

Some would say that The Thrown Ups really started the whole Seattle sound. With this record they finish it.

Really, Jack Endiro, December '93.

**The Thrownups:** *Seven Years Golden*
(front and back)
Art Director: Art Chantry
Designers: Art Chantry, Marla Katz, Judah
Creative Input: John Leighton Beezer
Photographer: Arthur S. Aubry
Client: Amphetamine Reptile Records

**Skeleton Key:** *Fantastic Spikes*
*Through Balloon*
Design Firm: Sagmeister, Inc.
Art Director: Stefan Sagmeister
Designers: Stefan Sagmeister, Hjalti Karlsson
Photographer: Tom Schierlitz
Client: Capitol Records

**Pat Metheny:** *Imaginary Day*
Design Firm: Sagmeister, Inc.
Art Director: Stefan Sagmeister
Designers: Stefan Sagmeister, Hjalti Karlsson
Photographer: Tom Schierlitz & stock
Client: Warner Bros. Records Inc.

# Identity

**Frank Ockenfels3**
Design Firm: Slatoff & Cohen Partners Inc.
Art Directors/Designers: Tamar Cohen,
David Slatoff
Client: Frank Ockenfels3

A logo must be simple. As the symbol of a corporation, business or organization, it embodies complex ideas and at the same is iconic—a veritable brand for those ideas. However, not all are so well endowed. Before the early twentieth century, logos were modeled on ornate heraldic shields. Like coats of arms, all manner of symbolic paraphernalia was woven in to form an entity that was more like a vignette than a mark. By the early twentieth century, the reduction process began to kick in, with extraneous graphic devices such as filigree, banners and sashes excised in favor of simplicity. Nevertheless, many marks were still burdened by representational iconography and had to be deciphered rather than experienced. The modern logo as we know it was born in Germany in the twenties and adopted throughout the world. In the late forties, the Swiss school further streamlined abstract graphic forms used as cornerstones in corporate identity systems. By the mid-fifties, American-based designers—including Paul Rand, Lester Beall and Erik Nitsche—achieved maximal impact with minimal geometries through marks that epitomize corporate modernism. Through the sixties and seventies, logos conformed to various period styles but shared the common root of economy. By the eighties, however, designers rejected cold, conformist approaches (notably Saul Bass's motion-line school of logo design) in favor of a return to illustrative marks that presumably evoked greater personality. While the reductive logo has not disappeared, more complex marks have reemerged—and some work very well. But ultimately, complexity offers diminishing return when memorability is the goal. Simplicity continues to be the root of a logo's mnemonic power.

**Utility Clothing Co.**
Design Firm: Charles S. Anderson Design Co.
Art Director: Charles S. Anderson
Designer: Todd Piper Hauswirth
Client: Target Stores

**Time Warner**
Design Firm: Chermayeff & Geismar Inc.
Art Director/Designer: Steff Geissbuhler
Client: Time Warner Inc.

**Out of Hand Tileworks**
Design Firm: Haley Johnson Design Co.
Designer/Illustrator: Haley Johnson
Client: Out of Hand Tileworks

**Logos**
Design Firm: Carmichael Lynch Thorburn
Designer: Chad Hagen
Illustrators: Chad Hagen, David Scrimpf
Client: Carmichael Lynch Thorburn

**East 42nd Street Salon**
Design Firm: Haley Johnson Design Company
Art Director: Haley Johnson
Designer: Richard Boynton
Illustrator: Richard Boynton
Client: East 42nd Street Salon

**GKV Design**
Design Firm: Office of Paul Sahre
Designer: Paul Sahre
Client: GKV Design

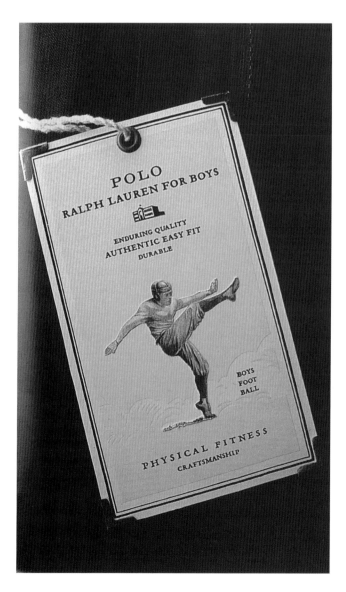

**The Globe**
Design Firm: Pentagram Design
Art Director/Designer: Paula Scher
Client: The Globe

**Polo: Ralph Lauren for Boys**
Design Firm: Charles S. Anderson Design Co.
Art Director: Charles S. Anderson
Designers: Charles S. Anderson, Dan Olsen
Client: Ralph Lauren

**Jackie Buck**
Design Firm: Studio d Design
Designer: Laurie DeMartino
Client: Jackie Buck

**Cafe 222**
Design Firm: Visual Asylum
Designer: MaeLin Levine
Client: Cafe 222

**Gallimard Album**
Design Firm: Delessert and Marshall
Designer: Rita Marshall
Client: Gallimard

**New 42nd Street press kit**
Design Firm: Chermayeff & Geismar Inc.
Art Director/Designer: Steff Geissbuhler
Client: The New 42nd Street Inc.

**Jager Di Paola Kemp**
Design Firm: Jager Di Paola Kemp Design
Creative Director: Michael Jager
Art Director: Davis Covell
Designer: Davis Covell
Client: Jager Di Paola Kemp Design

**Belkowitz Photography**
Design Firm: Studio d Design
Designer: Laurie DeMartino
Client: Belkowitz Photography + Film

**Jessica Helfand|William Drenttel**
Design Firm: Jessica Helfand|William Drenttel
Designers: Jessica Helfand, William Drenttel
Client: Jessica Helfand|William Drenttel

**Effect business card**
Design Firm: Tolleson Design
Art Director: Steve Tolleson
Designers: Steve Tolleson, Chase Watts
Illustrator: Richard Downs
Client: Effect

**K-RATION**
(front and back)
Design Firm: Charles S. Anderson Design Co.
Art Director: Charles S. Anderson
Designer: Todd Piper Hauswirth
Client: David Goodman, K-RATION

**Salisbury Studios**
Design Firm: Planet Design Co.
Designer: Jamie Karlin
Client: Salisbury Studios

**Matre Productions**
Design Firm: Haley Johnson Design Co.
Designer: Haley Johnson
Client: Matre Productions

**Jewelstar**
Design Firm: Carmichael Lynch Thorburn
Designer: David Schrimpf
Client: Jewelstar

**Planet Design Company**
Design Firm: Planet Design Co.
Art Directors: Kevin Wade, Dana Lytle
Designer: Martha Graettinger
Client: Planet Design Co.

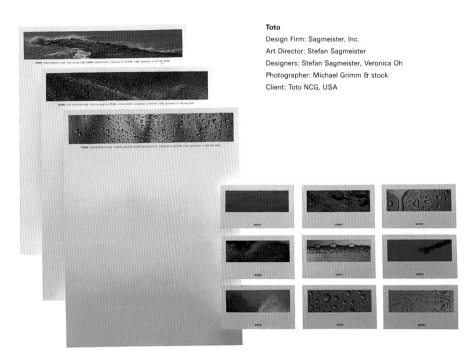

**Toto**
Design Firm: Sagmeister, Inc.
Art Director: Stefan Sagmeister
Designers: Stefan Sagmeister, Veronica Oh
Photographer: Michael Grimm & stock
Client: Toto NCG, USA

**Tea for Two**
Design Firm: Haley Johnson Design Co.
Designer/Photoillustrator: Richard Boynton
Illustrator: Haley Johnson
Client: Tea for Two

**Heltzer Incorporated**
Design Firm: Liska and Associates
Designer: Susan Carlson
Client: Heltzer Incorporated

**Logos**
Design Firm: BlackDog
Designer/Illustrator: Mark Fox

E-greetings Network

Zip2

PowerBar

San Francisco Museum of Modern Art Exhibition
Icons: Magnets of Meaning

# Magazines

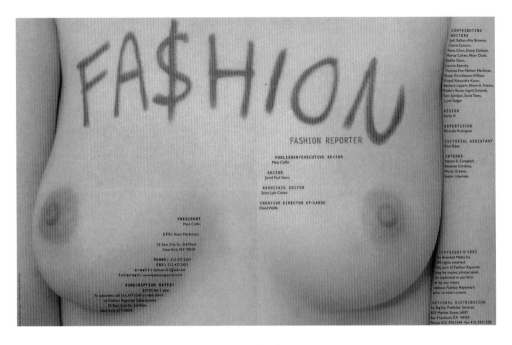

*Fashion Reporter* masthead
Design Firm: Socio X
Art Director: Bridget De Socio
Designer: Ninja von Oertzen
Photographer: Mark Lyon
Client: *Fashion Reporter*

*Magazin* is the French word for store and a magazine is a store-house of information. Like one of the grand French *magazins*, with its numerous departments of various goods, a magazine is loaded with text and images competing for attention. Designing a format to contain this content requires modulation and variation. A magazine is not simply a collection of contiguous clean pages, but disparate units tied together by an overriding aesthetic and efficiently paced to give a sense of motion and surprise. Invariably ads interrupt the flow of a magazine, and so a designer must be able to mitigate against the confusion that comes from the juxtaposition of editorial and advertisement—a problem that is not always successfully solved. In the fifties the best-designed magazines, among them *Portfolio, Mademoiselle* and *Seventeen*, used elegant typography to frame exciting visuals. Headline type did not scream, and body copy was a neutral color against images that stood out (but not apart). In the eighties magazine design took a turn towards the more raucous. One reason was the pendulum swinging against the previous generation, another was the nature of the media environment itself. Magazines were competing with electronic media, and readers

were conditioned to visual noise. Magazine covers, once an artistic realm, became prime editorial real estate for promoting the contents of the magazine. Coverlines cropped up like weeds, virtually obliterating the image. And editorial wells—which used to be uninterrupted spans on contiguous pages—were chopped up with advertising. In this context it might seem that simplicity would be a virtue, but complexity (excessive pull quotes, obtrusive headlines, other graphic detritus) became the norm. Owing to the complexity of the magazine form, "less is more" has never been easily attainable, but a modicum of simplicity has been reintroduced as both a critical response to the alternative, and as a means of managing the glut of text and visual material between covers. While the competitive marketplace demands that periodicals be graphically demonstrative, this does not rule out elegance and simplicity entirely. In fact, in a field of complexity, magazine designs based on less have a better chance of attracting attention.

**Talking Spaces**
Art Director/Designer: Michael Ian Kaye
Client: AIGA

**Language, Thought and Visual
Understanding**
Art Director/Designer: Michael Ian Kaye
Client: AIGA

*2wice:* Vol. 1, No. 1
Design Firm: Design/Writing/Research
Art Director/Designer: J. Abbott Miller
Associate Designers: Paul Carlos, Luke Hayman
Photographer: James Wojcik

*2wice:* Vol. 1, No. 2
Design Firm: Design/Writing/Research
Designer: J. Abbott Miller
Associate Designer: Scott Devendorf
Photographer: Robert Polidori

**Nozone #8:  Work**
Creative Director: Knickerbocker
Designer: Paul Sahre
Client: Knickerbocker

*Rolling Stone*

**"PJ Harvey"**
Art Director: Fred Woodward
Designers: Fred Woodward,
Gail Anderson
Photographer: Kate Garner

**"Dennis Rodman's Floating World"**
Art Directors: Fred Woodward,
Geraldine Hessler
Designer: Fred Woodward
Photographer: Albert Watson

**"Legends of Country Music"**
Designers: Fred Woodward,
Gail Anderson
Photographer: Mark Seliger

**"Balancing Act: Eddie Van Halen"**
Designers: Fred Woodward,
Geraldine Hessler
Photographer: Mark Seliger

**"What Does Conan O'Brien Have
That You Don't?"**
Designers: Fred Woodward,
Geraldine Hessler
Photographer: Mark Seliger

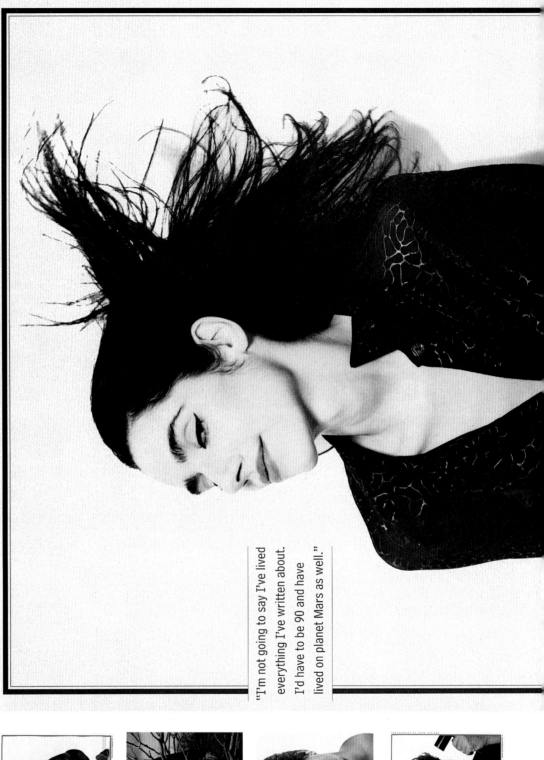

"I'm not going to say I've lived everything I've written about. I'd have to be 90 and have lived on planet Mars as well."

The New Theater Review
Fall 1994
Spring 1995
Fall 1995
Design Firm: Slatoff & Cohen Partners Inc.
Art Directors/Designers: Tamar Cohen,
David Slatoff
Client: Lincoln Center Theater

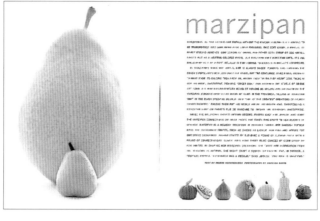

marzipan

caviar

*Martha Stewart Living*

**March 1997**
Art Director: Eric A. Pike
Designer: Claudia Bruno
Photographer: Victor Schrager

**April 1995**
Art Director: Eric A. Pike
Designer: Eric A. Pike
Photographer: Thibault Jeanson

**"Marzipan"**
Art Director: Eric A. Pike
Designer: Claudia Bruno
Photographer: Carlton Davis

**"Caviar"**
Designer: Eric A. Pike
Photographer: Carlton Davis

**"Meringue"**
Designer: Eric A. Pike
Photography: Victoria Pearson

**"Plums"**
Designer: Eric A. Pike
Photography: Victor Schrager

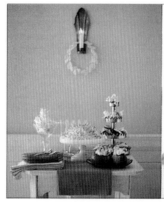

MERINGUE

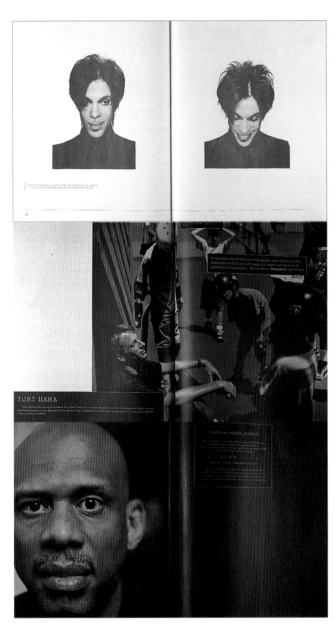

*Icon Thoughtstyle*

**"The Artist"**
Art Director: Cicero deGuzman, Jr.
Photographer: Alexei Hay

**"Tony Hawk"**
Art Director: Cicero deGuzman, Jr.
Photographer: Sean Murphy

**"Kareem Abdul-Jabbar"**
Art Director: Cicero deGuzman, Jr.
Photographer: Larry Sultan

*Obscure Objects*
**"Time Is an Object"**
Design Firm: Design Machine
Art Director/Designer: Alexander Gelman
Client: Obscure Objects Magazine

*Perspective*

**Fall 1997**
Design Firm: Concrete
Designers: Jilly Simons, Kelly Simpson
Photographer: Andre Baranowski/
Graphistock
Client: International Interior Design Assoc.

**Spring 1997**
Design Firm: Concrete
Designers: Jilly Simons, Kelly Simpson
Photographer: Hirokazu Jike/Photonica
Client: International Interior Design Assoc.

**Summer 1997**
Design Firm: Concrete
Designers: Jilly Simons, Kelly Simpson
Photographer: R.J. Muna/Graphistock
Client: International Interior Design Assoc.

# Packaging

Like a poster, a package has to attract the eye within seconds of its initial viewing. Some packages are familiar objects and prompt immediate responses. The unfamiliar ones must be both stop signs as well as triggers of impulsive behavior. In this sense the package is like the foot soldier in the war for the hearts and minds of the consumer. But a package is also a more benign container intended for protection and storage. Hence, many rules and regulations (some of them practical, others aesthetic) govern how package designers must create. The earliest packages were simple wrappers, but the first graphically designed packages from the late nineteenth century were covered with type and images, akin to the posters of the day. Since there were few competitors back then, a tin or box did not have to grab the purchaser's attention in such a short time frame. But as consumerism began to flourish during the early twentieth century and markets became flooded with packages, manufacturers, public relations experts and designers realized that these objects were much more than containers, they were advertisements too. Of course, three-dimensionality is the key difference between a package and other print media. Designing for nine sides of a box or a round tin requires a different kind of sensibility and planning than what is required for a flat surface. Historically, designers overdecorated the package as if to transform the quotidian product into something monumental. Yet soon shelves became cluttered with overwrought design. Simplicity is not always the rule, but it is certainly an important ingredient of successful packaging. The other is allure—the perfect color, logo or picture used to elicit the passion to purchase. "Less is more" in package design is relative, but the best examples are those that have a central focus, while conveying all the information the manufacturer, retailer and law demands.

Prince of Orange
**Orange Liqueur Pound Cake**
Design Firm: Michael Mabry Design
Art Director/Designer: Michael Mabry
Illustrator: Michael Mabry
Client: El Paso Chili Co.

Zélé
Design Firm: Michael Mabry Design
Art Director/Designer: Michael Mabry
Illustrator: Michael Mabry
Client: Seh Importers

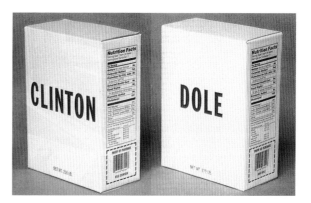

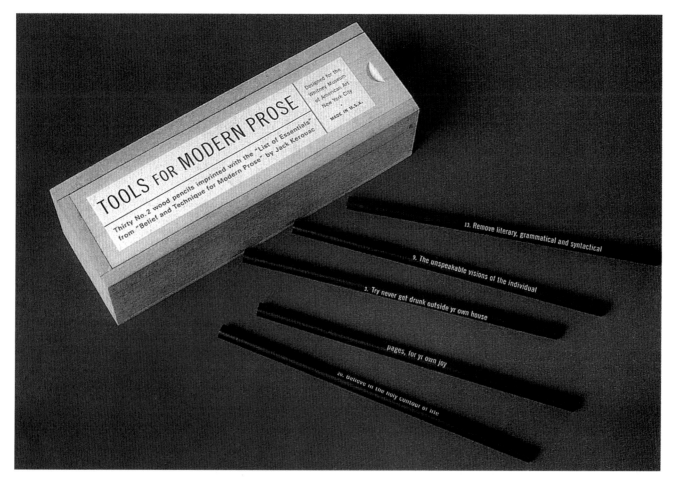

**Candidate Packaging**
Design Firm: Open
Concept/Designer: Scott Stowell
Client: *Creativity* magazine

**Tools for Modern Prose**
Design Firm: Open
Designer: Scott Stowell
Writer: Jack Kerouac
Client: Whitney Museum of American Art

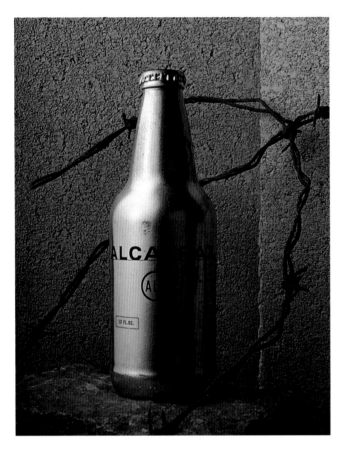

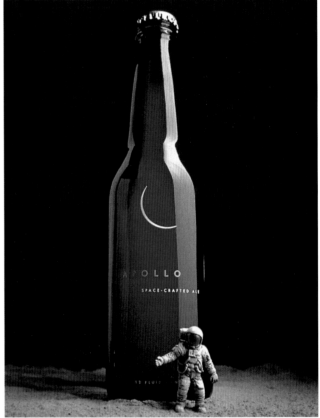

**Alcatraz Ale**
Design Firm: Cahan & Associates
Designer: Sharrie Brooks
Client: Alcatraz Ale

**Apollo Ale & Lager**
Design Firm: Cahan & Associates
Designer: Kevin Roberson
Client: Apollo Ale & Lager

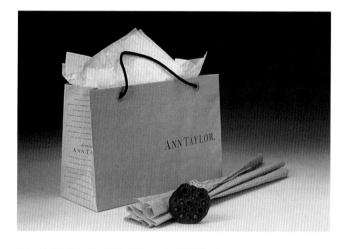

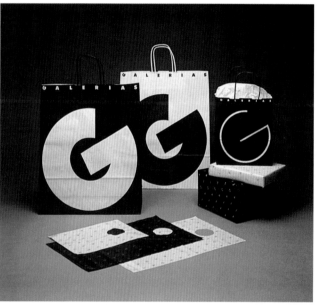

**Galerias Preciados**
Design Firm: Vignelli Associates
Designers: Massimo Vignelli, Lella Vignelli
Client: Terron Schaefer

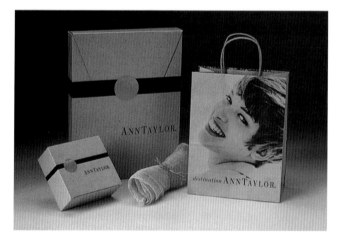

**Ann Taylor**
Design Firm: Desgrippes Gobé & Associates
Creative Director: Peter Levine
Primary Packaging: Kenneth Hirst
Design Director: Frances Ullenberg
Designers: Christopher Freas, Kin Tyska
Client: Ann Taylor

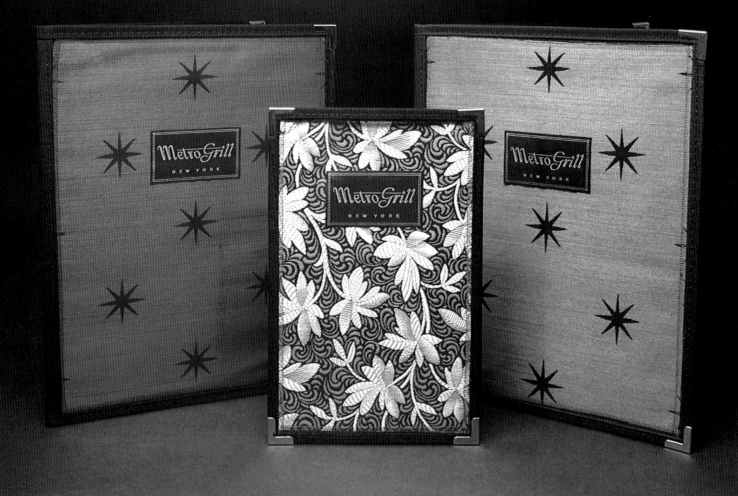

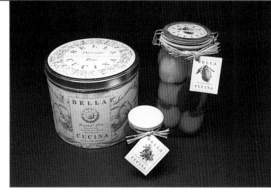

**Metro Grill**

**Bella Cucina**

**Picholine**

Design Firm: Louise Fili  Ltd.
Art Director: Louise Fili
Designers: Louise Fili, Mary Jane Callister

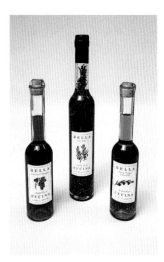

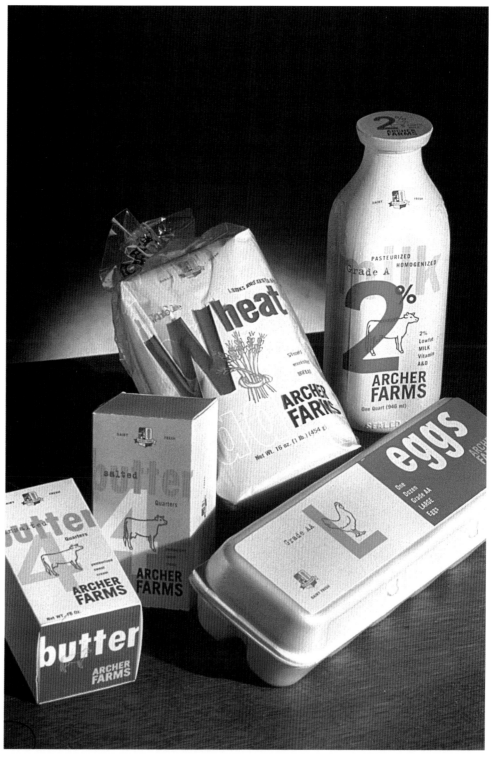

**Indochine hang tags**
Design Firm: Werner Design Werks, Inc.
Art Director: Sharon Werner
Designers: Sharon Werner, Sarah Nelson
Client: Indochine

**Archer Farms**
Design Firm: Werner Design Werks, Inc.
Art Director: Sharon Werner
Designers: Sharon Werner, Todd Bartz
Client: Target Stores

**G. H. Bass & Co.**
Design Firm: Pentagram Design
Art Director: Paula Scher
Designers: Paula Scher, Lisa Mazur
Client: G. H. Bass & Co.

**Smith Sunglasses**
Design Firm: Hornall Anderson Design
Works, Inc.
Art Director: Jack Anderson
Designers: Jack Anderson, David Bates
Client: Smith Sport Optics

**Softwear Shoes**
Design Firm: The Leonhardt Group, Inc.
Designer: Ted Leonhardt
Client: Nordstrom

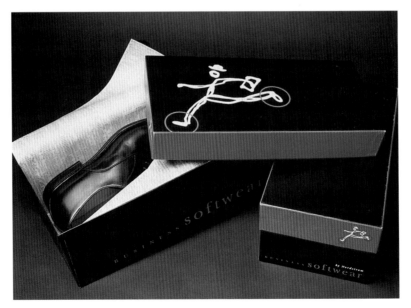

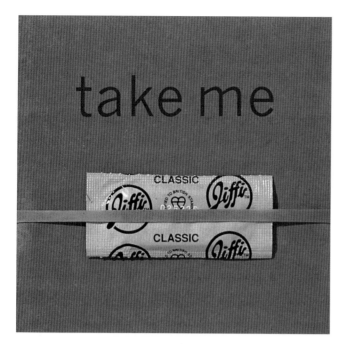

**Stress Relief Bath**
Design Firm: Lippa Pearce Design Ltd.
Art Director: Harry Pearce
Designers: Rachael Dinnis, Harry Pearce
Client: The Boots Company Plc.

**Take Me**
Design Firm: Lippa Pearce Design Ltd.
Art Director: Domenic Lippa
Designer: Mark Diaper
Photographer: Richard Foster
Client: The Terrence Higgins Trust

**Birkinserts Footwear**
Design Firm: Tolleson Design
Art Director: Steve Tolleson
Designers: Steve Tolleson, Chase Watts
Photographer: John Casado
Client: Birkenstock

**Shibure**
Design Firm: Studio Pepin
Art Director/Designer: José Conde
Client: Kawade Shobo Shinsha

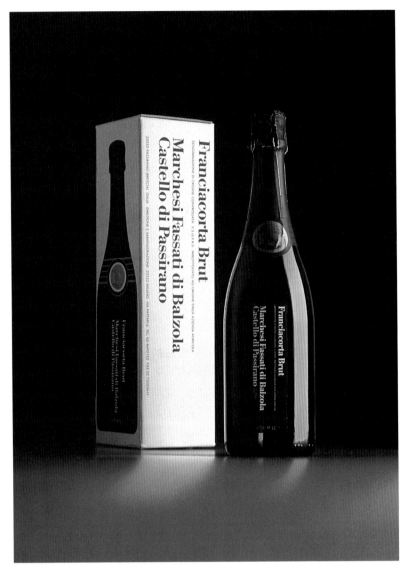

**New View**
Design Firm: Studio d Design
Designer: Laurie DeMartino
Client: New View

**Marchesi Fassati di Balzola**
Design Firm: Vignelli Associates
Designers: Massimo Vignelli, Dani Piderman
Client: Marchesi Fassati di Balzola Winery

**Target Christmas Lighting**
Design Firm: Seasonal Specialties LLC
Designer: Barbara J. Roth
Client: Target

**Beantown Soup Co.**
Design Firm: Louise Fili Ltd.
Art Director: Louise Fili
Designers: Louise Fili, Mary Jane Callister
Client: Beantown Soup Co.

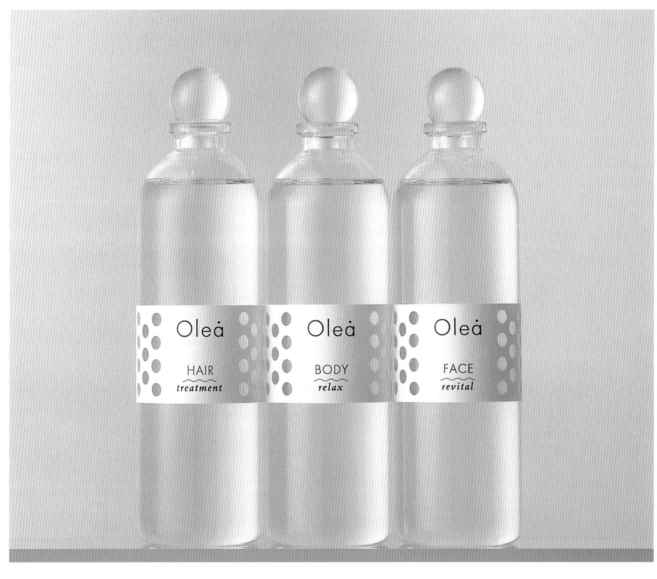

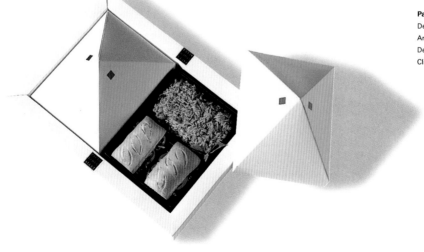

**Olea packaging**
Design Firm: Studio Pepin
Art Director/Designer: José Conde
Client: Olea Incorporated (South Africa)

**Paula Le Duc Allez**
Design Firm: Michael Mabry Design
Art Director: Michael Mabry
Designers: Michael Mabry, Peter Soe, Jr.
Client: Paula Le Duc Allez

# Posters

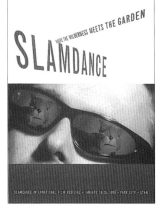

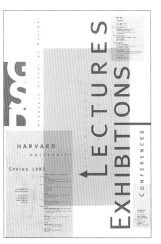

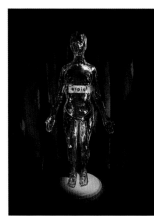

**Slamdance**
Design Firm: Adams Morioka
Art Director: Sean Adams
Designers: Sean Adams, Noreen Morioka
Client: Slamdance International Film Festival

**Harvard University: Lectures,
Exhibitions, Conferences**
Design Firm: Fahrenheit
Designer: Paul Montie
Client: Harvard University
Graduate School of Design

**April Greiman Lecture**
Design Firm: Office of Paul Sahre
Designer: Paul Sahre
Photographer: Michael Northrup
Client: AIGA Baltimore

**Mill Valley Film Festival**
Design Firm: BlackDog
Designer/Photographer: Mark Fox
Agency: Scheyer/SF
Client: Mill Valley Film Festival

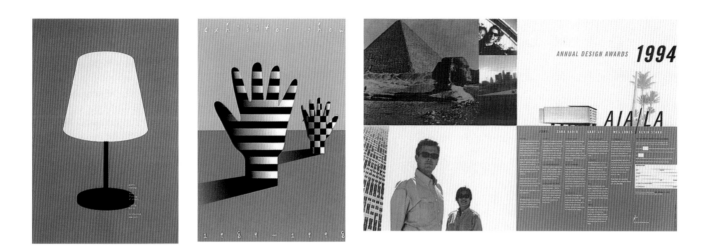

**Poetry Readings**
Design Firm: Design Machine
Designer: Alexander Gelman
Client: Biblio's

**Exhibitor Show**
Design Firm: Vanderbyl Design
Designer: Michael Vanderbyl
Client: California College of Arts & Crafts

**AIA/LA Annual Design Awards 1994**
Design Firm: Adams Morioka
Art Director: Sean Adams
Designers: Sean Adams, Noreen Morioka
Client: American Institute of Architecture/LA

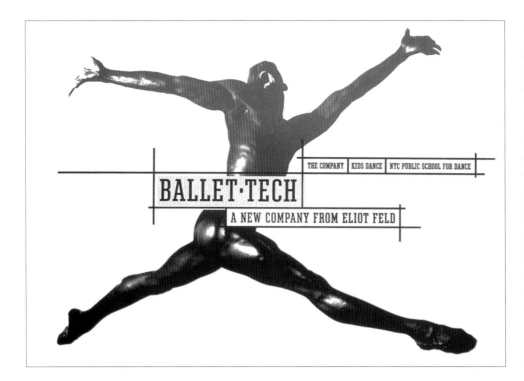

**Ballet-Tech**
Design Firm: Pentagram Design
Art Director: Paula Scher
Designer: Paula Scher
Photographer: Lois Greenfield
Client: Ballet-Tech

A poster is a single sheet of paper that is posted on walls, hoardings or any visible surface. In the late nineteenth century, posters were the main way to communicate messages to the public. They began as all type (in fact, a clutter of different typefaces and weights) and were created by printers. But when artists became involved, proportion and aesthetics were introduced. Focus was the watchword of poster design, a central image and stark lettering was indispensable. Posters were not, however, paradigms of simplicity. The early specimens may have had a central image, but were framed

by florid decoration and ornamentation. As posters filled the streets, and the streets filled with all kinds of vehicular traffic, passersby had little time to absorb the messages on individual posters. The most eye-catching poster was one that stood out against a sea of paper and ink, type and image. In the early nineteen hundreds, German designer Lucian Bernhard invented a style that insured widespread visibility called the *sachplakat*, or object poster, which was the quintessence of graphic simplicity. His posters were usually built upon brightly colored backgrounds against which the "object," or product being advertised, was rendered in a bold graphic manner with only the brand name drawn in a block letter. This method influenced other kinds of poster design and has defined the fundamental reductive approach to poster making. But not all posters are so lacking in artifice. Some posters or billboards are more additive in the hope that viewers will quickly process and retain more from the content. The psychedelic poster of the late sixties is a good example of turning the rules upside down (using vibrating colors and smashed and contorted letter forms), forcing viewers to study rather than browse through a poster. Complex and simple designs have always shared the stage. But in the eighties a large number of posters were not initially hung, but were sent through the mail. Since presumably a mailed poster (folding in quarters or eighths) might be more leisurely read, the design of these tended to be more layered. However, complexity in posters has limited usefulness. Currently, there is no so-called trend towards simplicity; simplicity has always been the most effective way to get the message across.

**Enigma**
Design Firm: BlackDog
Designer: Mark Fox
Client: AIGA Colorado

**Equus**
Design Firm: Fahrenheit
Designer/Illustrator: Paul Montie
Client: C. Walsh Theater, Suffolk University

**Cigarettes Shrink Dicks**
Design Firm: David Carson Design
Creative Director: Brendon Donovan
Designer: David Carson
Copy Writer: Tina Hall
Client: Citizens for a Smoke-Free World

**50 Books/50 Covers**
Design Firm: Jessica Helfand|William
Drenttel
Designers: Jessica Helfand, William Drenttel
Digital Photography: Cedar Graphics
Illustration: Joel Peter Johnson
Text: Sven Birkerts
Client: AIGA

**City Bakery Hot Chocolate Festival**
Designer/Photographer: Michael Ian Kaye
Client: City Bakery

**Architects at the Frying Pan**
Design Firm: Pentagram Design
Art Director/Designer: Michael Gericke
Client: American Institute of Architects, New York

Read

Literacy First

**Read: Literacy First**
Design Firm: Haley Johnson Design Co.
Art Director: Haley Johnson
Designers: Haley Johnson, Richard Boynton
Client: AIGA Colorado

**PS**
Design Firm: Office of Paul Sahre
Designer: Paul Sahre

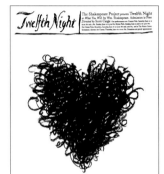

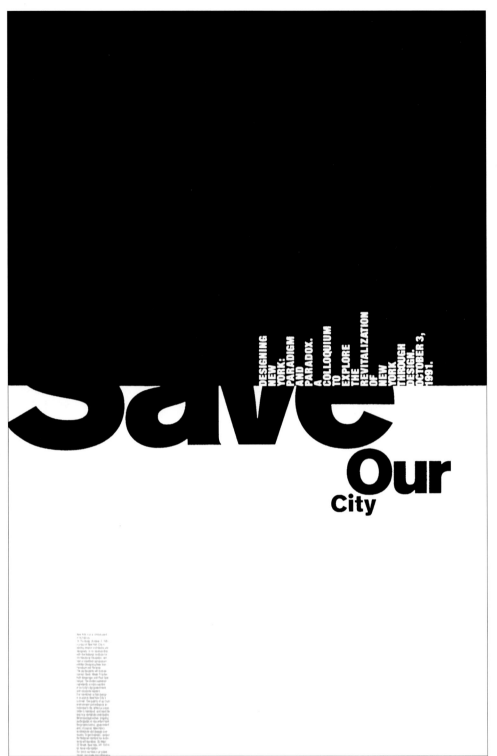

**Marie and Bruce**
Design Firm: Pentagram Design
Designer/Illustrator: Michael Bierut
Client: Parallax Theater Company

**Twelfth Night**
Design Firm: James Victore Inc.
Art Director: Scott Cargle
Client: The Shakespeare Project

**Shaping Culture**
Design Firm: Design Machine
Designer: Alexander Gelman
Client: The University of the Arts

**Save Our City**
Design Firm: Pentagram Design
Designer: Michael Bierut
Client: Designing New York

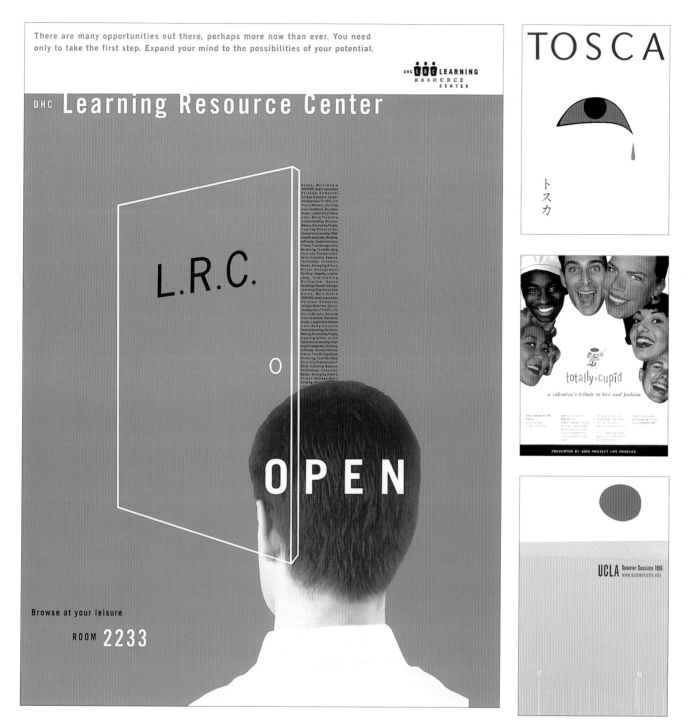

There are many opportunities out there, perhaps more now than ever. You need only to take the first step. Expand your mind to the possibilities of your potential.

DHC LRC LEARNING RESOURCE CENTER

DHC **Learning Resource Center**

L.R.C.

OPEN

Browse at your leisure

ROOM **2233**

TOSCA

トスカ

totally cupid
*a valentine's tribute to love and fashion*

PRESENTED BY AIDS PROJECT LOS ANGELES

UCLA Summer Sessions 1998
www.summer.ucla.edu

**Learning Resource Center**
Design Firm: Werner Design Werks, Inc.
Creative Director: Kim Aldrin
Art Director: Sharon Werner
Designers: Sharon Werner, Sarah Nelson
Client: Dayton Hudson Corporation

*Tosca*
Design Firm: Studio Pepín
Art Director/Designer: José Conde
Client: Fujiwara Opera, Tokyo

*Totally Cupid*
Design Firm: Adams Morioka
Art Director: Sean Adams
Designers: Sean Adams, Noreen Morioka
Client: AIDS Project Los Angeles

**UCLA Summer Sessions 1998**
Design Firm: Adams Morioka
Art Director: Sean Adams
Designers: Sean Adams, Noreen Morioka
Client: UCLA

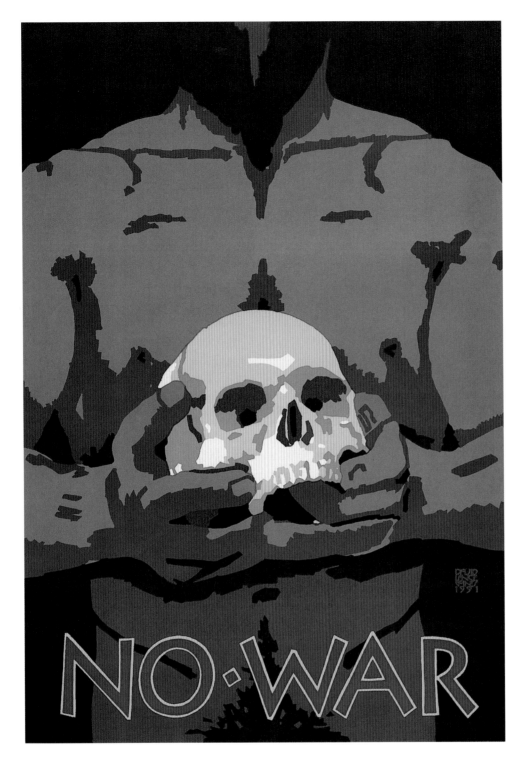

**No War**
Design Firm: St. Hieronymous Press
Designer: David Lance Goines
Client: St. Hieronymous Press

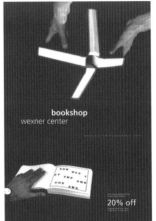

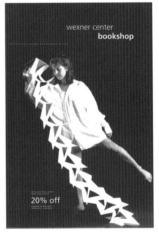

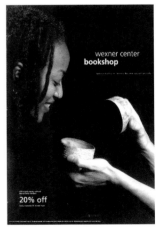

**Wexner Center Bookshop**
Designer: M. Christopher Jones
Photographer: Mark Teague
Vision: Robert Brooks
Client: Wexner Center for the Arts,
The Ohio State University

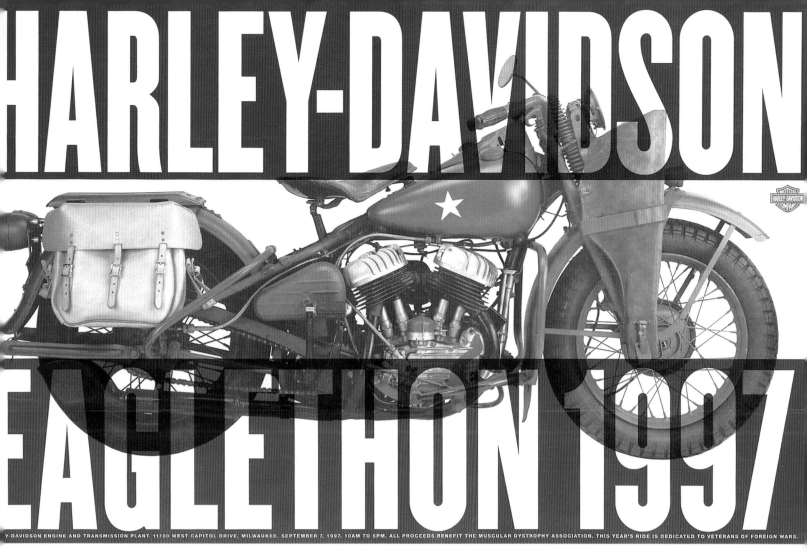

# HARLEY-DAVIDSON
# EAGLETHON 1997

V-DAVIDSON ENGINE AND TRANSMISSION PLANT. 11700 WEST CAPITOL DRIVE, MILWAUKEE. SEPTEMBER 7, 1997. 10AM TO 5PM. ALL PROCEEDS BENEFIT THE MUSCULAR DYSTROPHY ASSOCIATION. THIS YEAR'S RIDE IS DEDICATED TO VETERANS OF FOREIGN WARS.

**Harley-Davidson**
Design Firm: VSA Partners
Designers: Josh Schreiber, Ken Fox
Fletcher Martin
Client: Harley-Davidson, Inc.

**Use a Condom (flies/bunnies)**
Design Firm: James Victore Inc.
Designer: James Victore
Client: DDD Gallery

# Case Studies

Simplicity is seen but not easily explained. For some graphic designers it's second nature; for others it involves forethought. The examples in this section do not conform to any single set of criteria. Each project (or collection of projects) was developed as a response to particular problems, where "less is more" was the appropriate solution. One purposely follows classical traditions, another builds upon those traditions and evolves into a contemporary vocabulary, and still another uses minimalism as a contemporary alternative to the clutter of the recent past. Some of the projects represent a large body of work; others are simply individual components of a larger body. All indicate that reduction on any scale is an effective means of conveying messages.

**Dance Ink**

On the surface *Dance Ink* is not the epitome of simplicity, but it is a masterpiece of design eloquence. Art director/designer J. Abbott Miller used a diverse array of graphic elements in each issue and changed form and format from issue to issue. But with all the seismic shifts in its appearance, an overarching sensibility governed, rooted in order, hierarchy and simplicity, utilizing the magazine's fundamental resources.

*Dance Ink* was (it ceased publication in 1997) a uniquely literate, small circulation, quarterly journal, funded by a not-for-profit performing arts foundation, and devoted to presenting decidedly visual and kinetic art. "The agenda for the magazine," states Miller, "was to provide a platform for dance, which is ephemeral in nature, and to give it a powerful visual forum that showcased the dialectic between the photographer and the performer." *Dance Ink* is proof that a traditional typographic approach with contemporaneous applications is more viable, and curiously more mutable, than the fashionable, anti-design approach. "The magazine evolved over a period of six years," continues Miller, "beginning with a very controlled format which soon gave way to an extremely flexible, often thematic approach to the magazine's identity." Because *Dance Ink* was heavily subscription-based, rather than newsstand-oriented, Miller felt he could afford to mutate from issue to issue without confusing the readers.

The first couple of issues were resolutely spare, owing to limited means. The decision to print on uncoated stock using no more than two colors further underscored its shoestring budget. Early issues were visually noteworthy for striking black and white or duotone covers of dancers in heroic, contorted and even comic poses situated under or over a logo that changed from issue to issue. The cover was simple though bold, and the interior design was more sedate, with columns of ragged type simply laid out on a grid without any overlapping, layering or inter-line disbursement of supplementary text in the current typographic fashion that tries to suggest various voices or echo video screens.

Miller maintained allegiance to a type font called Scala, designed by Dutch designer Martin Majoor. "Scala epitomized the dynamic between classicism and modernism that was central to the arena of dance that formed our subject," explains Miller. "The entire first few years of the magazine were sort of like a love letter to Scala (or Majoor), but later, as our content varied, the design approach become more heterogeneous." By the Summer 1993 issue, full color was introduced on the cover, with some spot color on

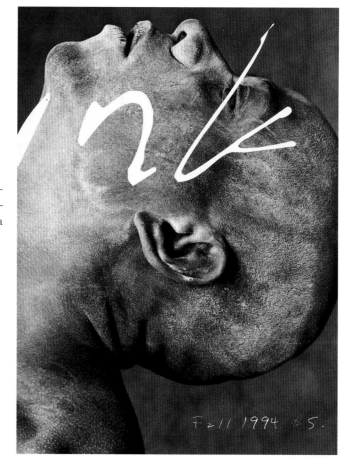

selected inside pages. The paper stock, though still comparatively inexpensive, was also upgraded to give the magazine a substantial tactile sensation. *Dance Ink* bridged the gap between art catalog and magazine.

In describing the look and feel of the later issues, Miller asserts that he used the poles of classicism and modernism to express a wide range of performance. "The design did not set out to be deliberately simple or minimalist; rather, the idea for a particular spread sometimes required a degree of editing to allow the idea to come through." Often the "less is more" stereotype was eschewed in favor of more attention to particular design details or stylistic mannerisms, but never in such a way as to overpower the text or image. "I don't associate simplicity with 'turning down the volume,'" Miller says, responding to the question of whether or not he consciously squelched an impulse to graphically scream. "I think it has more to do with clearing out the static or noise. I would rephrase the question in terms of editing, refinement, focus, clarification." Ultimately, during its brief existence, *Dance Ink* clarified how a marriage of the tenets of classicism and modernism became a distinct format wherein the notions of time and fashion were unimportant.

*Dance Ink* Fall 1994
Design Firm: Design/Writing/Research
Art Director: J. Abbott Miller
Designers: J. Abbott Miller, Hall Smyth

*Dance Ink* **Summer 1996**
Design Firm: Design/Writing/Research
Art Director: J. Abbott Miller
Designers: J. Abbott Miller, Paul Carlos

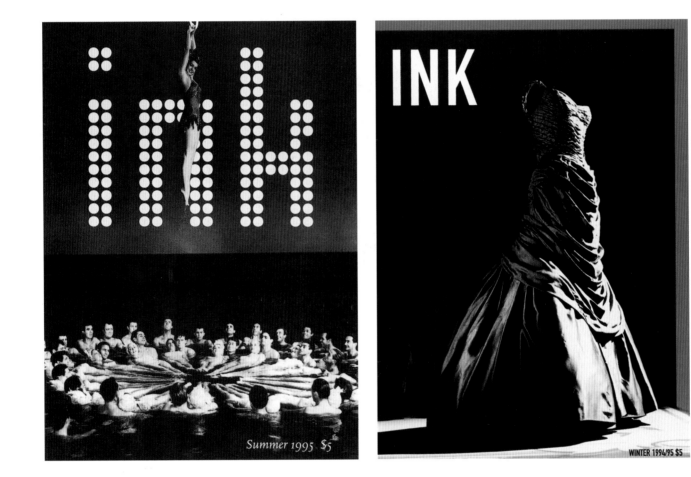

*Dance Ink* **Summer 1995**
Design Firm: Design/Writing/Research
Art Director: J. Abbott Miller
Designers: J. Abbott Miller, Paul Carlos

*Dance Ink* **Winter 1994/95**
Design Firm: Design/Writing/Research
Art Director: J. Abbott Miller
Designers: J. Abbott Miller, Hall Smyth

*Dance Ink* **Summer 1996**
Design Firm: Design/Writing/Research
Art Director: J. Abbott Miller
Designers: J. Abbott Miller, Paul Carlos

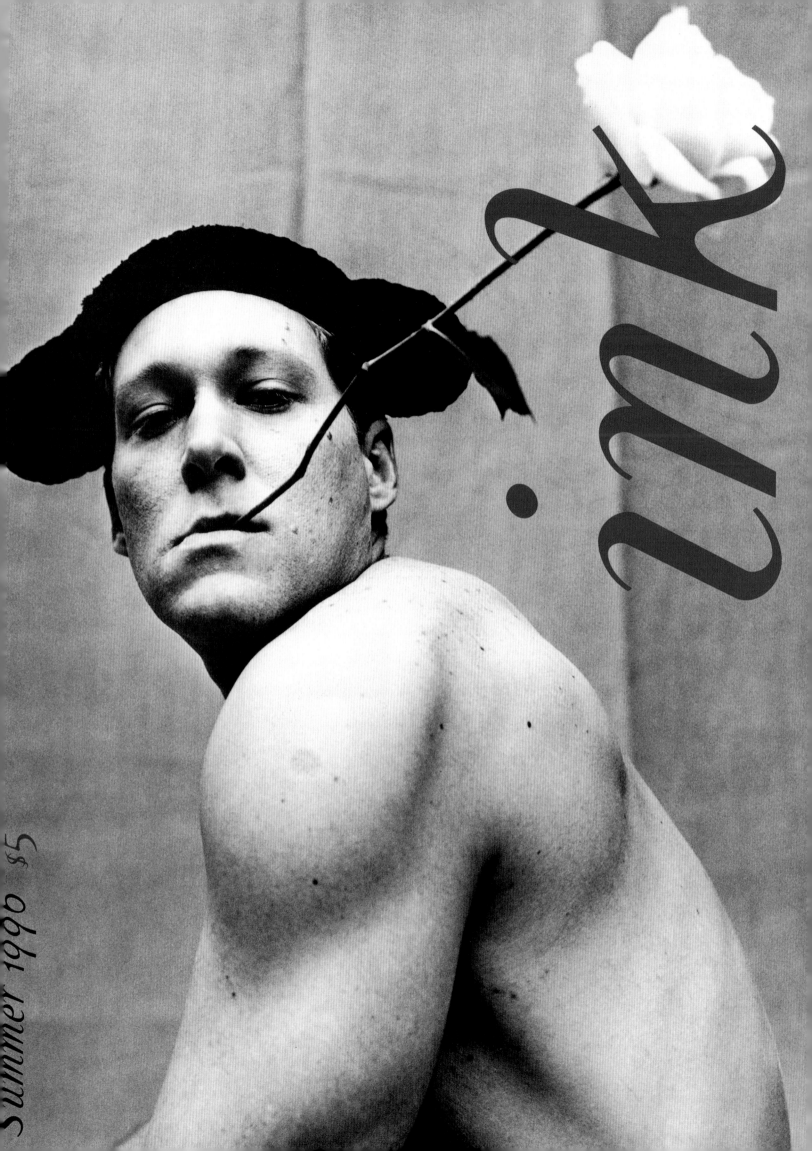

summer 1990 $5

ink

Chicago Board of Trade

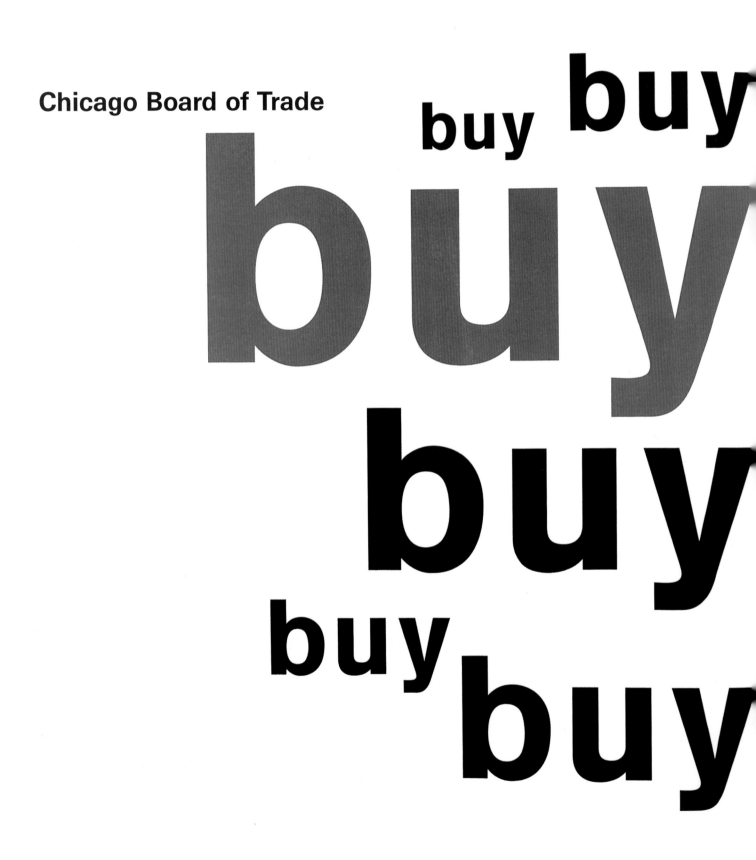

For design firms who are so engaged, "annual report season" is akin to hurricane season, always regular, never dull, and often frightening. Critical masses of activity are compressed into short time periods—conceptualizing, designing, photographing, illustrating, chart making, producing, printing, binding, and oops, correcting mistakes after the average stockholder finds the one typo that everybody overlooked. The stakes are high because this is a company's single most relevant instrument of outreach. It is, therefore, one of the most scrutinized of all graphic design projects and the most difficult to make unique from year to year.

Most corporations toe a fairly conservative line. But occasionally, the marriage of a progressive corporate director of communications and an imaginative designer results in a report that avoids the cliches, busts the stereotypes and becomes an object of such beauty and intelligence that it almost transcends its purpose. This is true for the Chicago Board of Trade reports designed by VSA Partners from 1990 to 1995.

"The director of communications for the CBOT, America's leading futures market, was always very clear and simple regarding the direction for his annual report," relates Dana Arnett, a VSA principal. "He said: 'Bring me your best thinking.'" This involved an editorial plan to build stories around the people, practices and events that separated the CBOT brand from the other world trading exchanges. "Since most of the reports were photo-driven, we have always pushed our collaborative skills to break ground in expressing new forms of visual language," continues Arnett. The CBOT reports are also rooted in a storytelling process akin to dramatic documentary film. "All the collaborators will concur that among the myriad report elements, photography, typography, paper, writing and more, story is pre-eminent," he says.

To tell these stories well, Arnett demands design clarity. "My design by nature is rooted in the tenets of classical typography, simple and direct visuals, powerful headlines." For CBOT, Arnett juxtaposed classical elements against modern subject matter, which he insists provided the reader with a level of "intrigue and perspect." Simply put, the design exudes history while emphasizing the here and now.

Arnett stresses that each report is different, but with a common reference to the life of the CBOT. "We did not want this series of reports to look like a 'vanilla-fest.'" In fact, one of them was designed with Cooper Black, designed by Chicago-based Oswald Cooper in the twenties, and a rather unusual face for this genre. "To me," explains Arnett, "the face is Chicago and became part of the annual's identity."

"Design by nature is all about structure and capacity," says Arnett. "How can we take an idea, within the appropriate context, and stretch the expression? I am always intrigued by the challenge of creating a new voice out of classical elements." But he warns that designing within the context of simplicity will only succeed "if the expression challenges the nature or definition of 'simple.'" He quotes Paul Rand's dictum that "simple doesn't mean plain." The essence of uniqueness occurs as a conflict between simple and complex changes, transforming, says Arnett, "that which we take for granted."

In terms of the CBOT reports, the tension between "classical design elements" and contemporary execution results in a dynamic interplay. "We turned up the volume through scaling up photos to help tell the story," says Arnett. "Our work is loud and full of energy...and the report was composed of simple elements to strike nerves of energy to engage the reader as if a trade floor participant. We wanted the reader to feel exhausted when they were through, just as they would experience a day of trading on the exchange."

**1990**
Design Firm: VSA Partners
Art Director: Dana Arnett
Senior Designer: Curt Schreiber
Writers: Michael Oakes, Anita Liskey
Photographer: François Robert
Client: Chicago Board of Trade

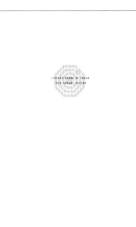

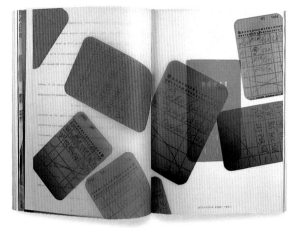

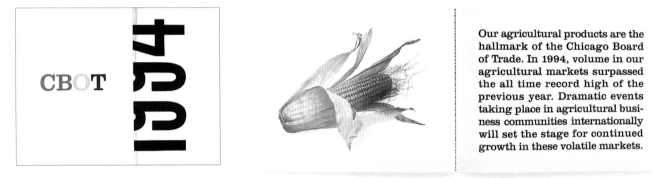

Our agricultural products are the hallmark of the Chicago Board of Trade. In 1994, volume in our agricultural markets surpassed the all time record high of the previous year. Dramatic events taking place in agricultural business communities internationally will set the stage for continued growth in these volatile markets.

**1994**
Design Firm: VSA Partners
Art Director: Dana Arnett
Senior Designer: Curt Schreiber
Writers: Anita Liskey, Michael Oakes
Photographer: François Robert
Client: Chicago Board of Trade

**1995**
Design Firm: VSA Partners
Art Director: Dana Arnett
Senior Designers: Curt Schreiber,
Fletcher Martin
Writer: Mike Prout
Client: Chicago Board of Trade

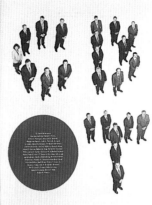

international marketplace, the nation's
rapidly expanding over-the-counter
market as well as new and ongoing
regulatory hurdles threatened to
undermine the performance and con-
tinued success of the CBOT.

To address these issues and ensure
that the exchange can remain competi-
tive, the CBOT continued its efforts to
educate Congressional decision makers
and members of the new Administration
about the CBOT's futures markets and
the impact regulatory differences can
have on the U.S. futures industry.

In June, the CBOT filed a petition
with the Commodity Futures Trading
Commission requesting an opportunity
to exempt markets from regulation
where only "professional traders"
are allowed to trade. If granted, this
exemption will play an important role
in enabling the exchange to expand its
ability to offer a wide variety of new
products and services demanded by
today's investment community.

Ironically, even the exchange's
dynamic growth brought a difficult
challenge for the exchange. The surge
in volume further stressed the already
overcrowded space in the CBOT's finan-
cial trading room. To alleviate some
of the space restrictions, the exchange
initiated and completed a multi-million
dollar renovation of the financial floor.
These improvements, which include
larger trading pits for the growing
interest rate complex and more booth
space, have already generated more
trading activity and more business.

However, this is a stopgap
solution at best. Additional
trading space remains one

of the biggest challenges to the
exchange's future. In January of 1994,
the Board of Directors of the CBOT pre-
sented a proposal for a new trading
facility to the exchange membership
which was overwhelmingly approved
in a ballot vote.

Despite the obstacles, the CBOT is
poised for continued growth. All indi-
cations show that volume will remain
robust for the rest of the decade and
well into the 21st century. Around the
world, while nations such as those in
Asia and Eastern Europe continue to
change from planned economies to
market economies, more opportunities
will be created for the world's
investors. Hand in hand with that
increased opportunity will be increased
risks. And, as the world knows, when-
ever there is market risk, there is an
increased need for the superior risk
management tools provided at the CBOT.

Our top priority is to do everything
possible to bring more orders to the
exchange's trading floor, and we
remain committed to that goal in 1994.

We invite you to continue reading
for a more detailed explanation of the
current status of the world's leading
futures exchange as well as for a pre-
view of our exciting plans for its future.

12

open

1993
Design Firm: VSA Partners
Art Director: Dana Arnett
Senior Designer: Curt Schreiber
Writers: Anita Liskey, Michael Oakes
Photographer: François Robert
Client: Chicago Board of Trade

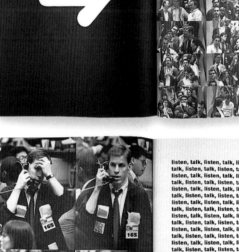

listen, talk, listen, talk, listen, talk, listen, talk
talk, listen, talk, listen, talk, listen, talk, listen
listen, talk, listen, talk, listen, talk, listen, talk
talk, listen, talk, listen, talk, listen, talk, listen
listen, talk, listen, talk, listen, talk, listen, talk
talk, listen, talk, listen, talk, listen, talk, listen
listen, talk, listen, talk, listen, talk, listen, talk
talk, listen, talk, listen, talk, listen, talk, listen
listen, talk, listen, talk, listen, talk, listen, talk
talk, listen, talk, listen, talk, listen, talk, listen
listen, talk, listen, talk, listen, talk, listen, talk
talk, listen, talk, listen, talk, listen, talk, listen
listen, talk, listen, talk, listen, talk, listen, talk
talk, listen, talk, listen, talk, listen, talk, listen
listen, talk, listen, talk, listen, talk, listen, talk
talk, listen, talk, listen, talk, listen, talk, listen
listen, talk, listen, talk, listen, talk, listen, talk
talk, listen, talk, listen, talk, listen, talk, listen
listen, talk, listen, talk, listen, talk, listen, talk
talk, listen, talk, listen, talk, listen, talk, listen
listen, talk, listen, talk, listen, talk, listen, talk
talk, listen, talk, listen, talk, listen, talk, listen
listen, talk, listen, talk, listen, talk, listen, talk
talk, listen, talk, listen, talk, listen, talk, listen
listen, talk, listen, talk, listen, talk, listen, talk

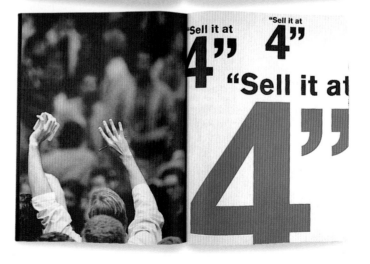

"Sell it at 4" 4"
"Sell it at 4"

# Benefit

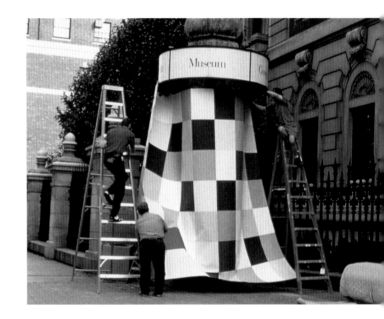

The most enjoyable part of being a graphic designer is the ability to develop an identity, personality or character for an entire entity, product or message over a period of time. From prototype through execution, the process of developing a consistent theme with variants and divergence is like participating in the stages of a child's development (albeit over a shorter period, but with just as much hassle at times). Drenttel Doyle Partners's (now Doyle Partners) work on Champion's Benefit line of recycled paper is both a case study of a successful promotional campaign and a vivid example of how graphic design defines not only a product but the zeitgeist. It is a story of the care, breeding and feeding of a branding project that grew into a strong contender in its particular market.

Big claim? Maybe. Hype? No. In the commercial paper field, where designers are constantly trying to outshine one another with one promotion more extravagant than the next, Benefit truly shines for its restraint that is, nevertheless, consistently surprising. Stephen Doyle's design scheme, based on a variety of decorative patterns and a distinctive muted color palette (soft greens, oranges, beiges and off-whites), owes a debt to such early twentieth-century design movements as the Wiener Werkstätte and the Vienna Secession, but is decidedly contemporary. The strategy is based on the notion that suites of different appealing patterns, linked through consistent type and limited color, will establish (over time) a recognition factor and a sense of anticipation for the subsequent products.

In addition to advertisements and specimen sheets, the materials in this series run the gamut from blank books, postcards and note pads to soap and pencil packages. Each are little gifts that sample the paper and leave a utilitarian reminder. Doyle even designed a special Champion Benefit car, an embellished old Rambler, using his emblematic colors and

patterns to help promote the paper and the ancillary products to AIGA conferees at their 1997 fete in New Orleans.

The budget for this campaign was not simple (or cheap), but the idea behind what Champion calls the "seasonal flux" of the "fashion-oriented" materials is rooted entirely in simplicity. "Less is more" is not the operative term here, since releasing more and more on a regular basis bolstered the memorability of the brand. Because of the continual bombardment of potential customers with these pieces, the basic design, characterized by harlequin patterns on some items and simple grids of colors on others, can afford to be understated.

In addition to the books and packages, Doyle developed an expansive series of postcards with weird, silly and useless facts printed on different colors and weights of Benefit. Designed with a nod to an eclectic view of typographic history (mixing swashes, slab serifs, Romans and sans serifs), including classical and modern-looking specimens, the critical mass of these things is complex, but individually each is a masterpiece of design restraint. And even when seen together, the differing typographic approaches do not fight tooth and nail, but evoke a demonstrative quietude.

Doyle's design for the Benefit line provides an unmistakable identity for the product. But it is further indicative of the manner with which he designs in general. No two clients are ever given cookie-cutter solutions, yet an overriding Doyle sensibility of the subtleties of type and the nuance of composition, the combination of tradition and contemporaneity, are evoked in every piece as unselfconscious simplicity.

**Benefit Portfolio**

**Benefit pattern wrapping the kiosk of the
National Design Museum**
Design Firm: Doyle Partners
Creative Director: Stephen Doyle
Client: Champion Paper

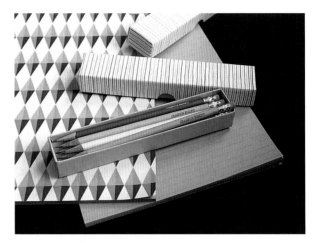

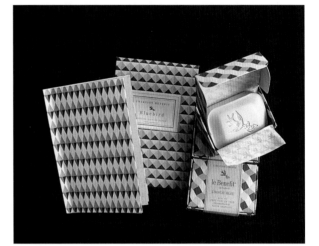

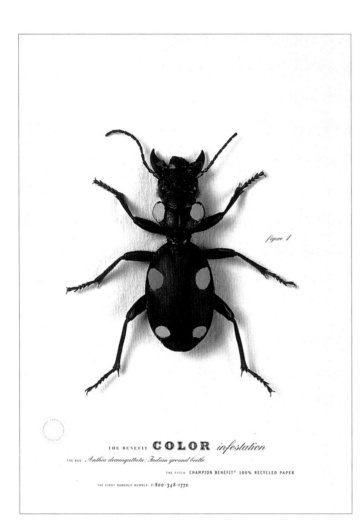

figure 1

THE BENEFIT **COLOR** infestation

THE BUG *Anthia decemguttata: Indian ground beetle*

THE PITCH CHAMPION BENEFIT® 100% RECYCLED PAPER

THE EIGHT HUNDRED NUMBER *1-800-348-1770*

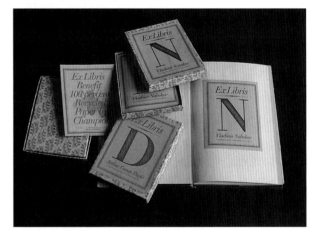

**Benefit**

(facing page)
Bug advertisement
Pencils and writing tablet
Bluebird soap and journal
Bookplates
Color theory
(this page)
Book of Days
Benefit Rambler
Clock
Benefit notecards
Color system advertisement

Design Firm: Doyle Partners
Creative Director: Stephen Doyle
Client: Champion Paper

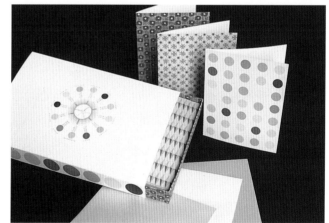

# Jerry Kelly

Contemporary book design builds on a long history that includes the ancient scribes, the sixth-century Venetian printers, and Gutenberg's invention of the printing press in the fifteenth century. The basic form of the book has not radically changed since its inception, but printing technology and design fashions have altered the book's physical appearance. During the twentieth century, designers have radically tested readers' tolerance through experiments where traditional pathways are disrupted.

This is not something one will find as a rule in books designed by Jerry Kelly, who, in addition to designing books, is a vice president of Stinehour Press, a venerable firm known for its fine letterpress printing. In an age when the distinctions that once divided book design specialists from other graphic designers have broken down, Kelly is a staunch "bookman" and scholar of book tradition. Not a generalist who dabbles in a multitude of old and new media, he continues to hone his craft just as his predecessors did. Thus, the examples shown here are not "less is more" as a stylistic whim, but rather as a consistent methodology that defines Kelly's work.

"In general I try to determine what would be appropriate for the project at hand," Kelly explains. "Sometimes a classical look, sometimes an archaic look, and sometimes a somewhat non-traditional look would best suit the subject matter." For Kenneth Lohf's book *Hours*, the poems were based on the liturgical Books of Hours, with divisions into parts of the day as done in the fifteenth century. Using a renaissance type with the liturgical practice of ruling margins in red was an appropriate metaphor. *Northering*, on the other hand, was written by a poet in the style of Robert Frost, so Kelly used the rugged Bulmer and Baskerville types, combined with a Nason wood engraving. In both instances the binding and papers reflected the same thinking: a marbled paper and laid rag stock for *Hours*; a rough

linen cloth and cream wove paper for *Northering*. The book of poems by the modern poet William Bronk, *The Choice of Words*, used more modern type in an asymmetric arrangement, in keeping with the contemporary nature of the poems.

"I always start with simplicity and work out from that point," says Kelly. "There has to be a reason to add any elements, such as illustration, font changes, different sizes, etc. That said, I believe there almost always is plenty of reason to add the most basic of designs, but this should be done in an appropriate way, and in such a manner that it does not hinder the readability or suitableness of the typography."

Despite Kelly's indebtedness to tradition, his book designs are not imitations of bygone epochs. As he repeats often, suitability governs his decisions. Ultimately a book design that is "of its time" is more appropriate than an ancient relic out of time. Yet Kelly states that a more suitable alternative to the overall question "why simplicity?" in his work, is "why not simplicity?" He believes that this is the root of all design. "One should not strip away at things to arrive at simplicity." He adds that "to design a project in one style and size of type, with no additional effects, is a fascinating challenge. There have been many successful attempts at this, which at first do not look as simple as they really are." What Kelly strives for is the appearance of simplicity in something that is structurally complex.

Nevertheless, Kelly admits that he has set type on a diagonal, used fonts that "I feel in general belong in the trash bin," bled elements off the page, dropped out letters, bounced baselines and more. "But only when suited to the project." Certain modern ideas about layered type and new, popular fonts have found their way into his work. "But I hope that I would never strain the project to fit the current style; rather the current styles feed in to a repertoire from which certain elements can be applied...if suitable."

*Hours*
Designer: Jerry Kelly
Client: Kenneth A. Lohf

***Against the Tide***
Designer: Jerry Kelly
Client: Glenn Horowitz

**Poets in a War**
Designer: Jerry Kelly
Client: Kenneth A. Lohf

**What Keats Looked Like**
Designer: Jerry Kelly
Publisher: Kelly-Winterton Press

**The Choice of Words**
Designer: Jerry Kelly
Publisher: James L. Weil

**Northering**
Designer: Jerry Kelly
Publisher: The Stinehour Press

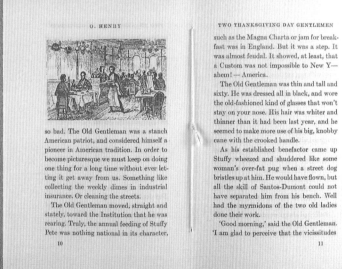

**Two Thanksgiving Day Gentlemen**
Designer: Jerry Kelly
Publisher: A. Colish, Inc.

"An Upward Spiral"
Art Director: Janet Froelich
Designer: Catherine Gilmore-Barnes
Photographer: Javier Vallhonrat

# The New York Times Magazine

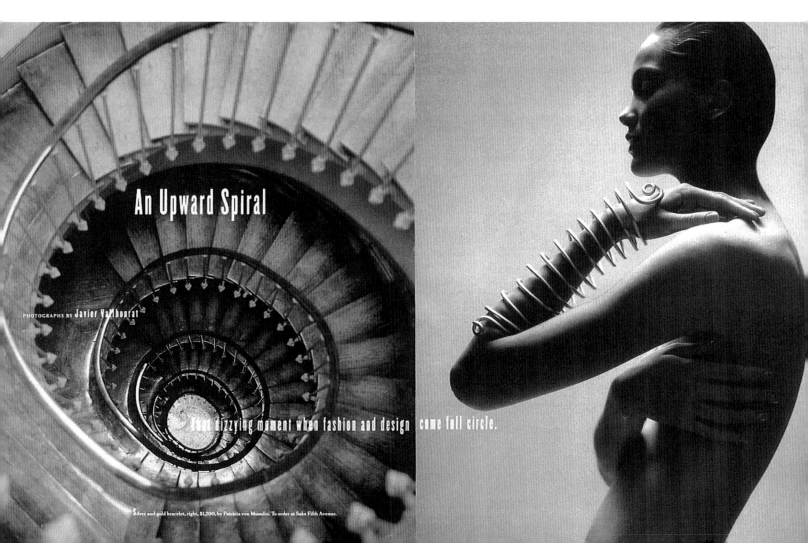

An Upward Spiral

PHOTOGRAPHS BY Javier Vallhonrat

That dizzying moment when fashion and design come full circle.

Silver and gold bracelet, right, $1,200, by Patricia von Musulin. To order at Saks Fifth Avenue.

The Sunday *New York Times Magazine* was originally published on Wednesdays and titled *The MidWeek Pictorial*, a rotogravure, broadsheet section of newsworthy photographs. In the thirties it was transformed into a Sunday magazine supplement devoted to feature stories on news events. Over the ensuing decades it was redesigned many times to improve utility and aesthetics. Although it has consistently conformed to a *New York Times* "style," the magazine has always been more feature-oriented than the hard and soft news sections of the paper.

During the early nineties, the time was right for a reappraisal of the format that had been operative for over a decade. "We began to reexamine *The New York Times Magazine* from the vantage point of clean, consistent design," states Janet Froelich, art director. "Our goal was to create a unique visual environment that was instantly recognizable to the reader." Accepting that the magazine had eclectic content—running the gamut from news to fashion—the decision was reached to return to a "simple and powerful" design as a means to hold everything together. Prior design incarnations were somewhat more varied and complex. "We also knew that our audience was somewhat conservative, and that although we didn't want to shock them, we didn't want to put them to sleep, either," adds Froelich.

Paula Scher of Pentagram was commissioned to develop a prototype under Froelich's supervision. One of the key considerations that governed the new approach was the magazine's graphic history, which always emphasized clarity and readability over clutter and fashion. "We eschewed design for its own sake, preferring instead to be driven by reason and concept," continues Froelich. Guided by the words "journalistic integrity," the fundamental plan to keep the design simple forced both the prototype and later staff designers to refrain from (as Froelich says) "over-decorating." The initial redesign reduced a diverse typographic palette to one display typeface, Cheltenham, used for headlines in the news sections. After the launch of the new design, however, there was a period of working out the kinks, rectifying the weaknesses, and capitalizing on the strength of the minimalist format.

The magazine is designed by a team of designers, and although each member conforms to the strict infrastructure and style dictates, there is also room for diversity and surprise. "Part of my task is to monitor the many strong sensibilities at work," explains Froelich, "to keep them all similarly focused." The designers understand that the magazine's mission is to tell stories so that they are accessible to the large (and sophisticated) audience of *Times* readers. Froelich says that the design principles support this: "We remain fiercely journalistic, our graphics are clear and simple, we limit our typography to few fonts [for special issues, fonts other than Cheltenham are used]."

Visual hierarchy—sizes and weights of type, scale and cropping of images—underscores the efficiency of this format. The reader has to instantly grasp the significance of a certain story, so the play of type and image must telescope this as quickly as possible. "To the reader," emphasizes Froelich, "the design approach should feel secondary, almost subliminal." Although pages and spreads include various graphic entry points (blurbs, decks, etc.) nothing is overly obtrusive. Each feature varies in subtle ways to distinguish shifts in content, but overall the whole is recognized as sacrosanct.

Most of the pages shown here are built on an image or series of images. "In the case of a news-driven story, the choice of photograph is dictated by the event and the eye of the photographer," says Froelich. "In the case of an essay, the image is conceptually driven." On occasion the type becomes the image, or central focus of the page, consistent with the overall typographic sensibility. Even if layering is used as an approach, Froelich insists "the reader should understand the whole page instantly.... Complexity should develop slowly, as one reads into the page."

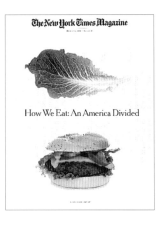

"How We Eat: An America Divided"
Art Director: Janet Froelich
Designer: Lisa Naftolin
Photographer: Kenji Toma

"Some Enchanted Evening Clothes"
Art Director/Designer: Janet Froelich
Photographer: Lillian Bassman
Stylist: Franciscus Ankoné

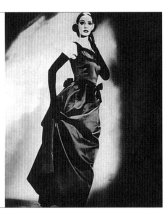

"James Is a Girl"
Art Director: Janet Froelich
Designers: Lisa Naftolin, Joele Cuyler
Photographer: Nan Goldin
Photo Editor: Kathy Ryan

"At 16: A Model's Life"
Art Director: Janet Froelich
Designer: Joele Cuyler
Photographer: Nan Goldin
Photo Editor: Kathy Ryan

"The New Jazz Age"
Art Director: Janet Froelich
Designer: Lisa Naftolin
Photographer: Richard Burbridge
Photo Editor: Kathy Ryan

"The Girls Next Door"
Art Director: Janet Froelich
Designer: Joele Cuyler
Artist: Alex Katz

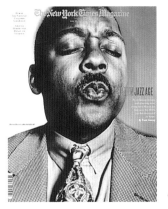

"There's No Place Like Work"
Art Director: Janet Froelich
Designer: Lisa Naftolin
Photographer: Victor Schrager

"Effacing Ourselves"
Art Director: Janet Froelich
Designer: Joele Cuyler
Photographers: Valery Gerlovina, Rimma
Gerlovina

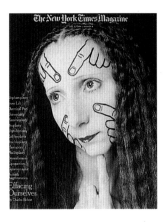

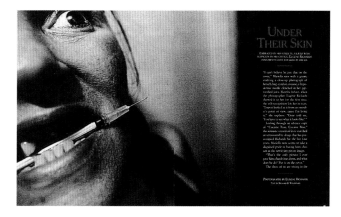

**"Under Their Skin"**
Art Director: Janet Froelich
Designer: Richard Baker
Photographer: Eugene Richard
Photo Editor: Kathy Ryan

**"The Next 100 Years"**
Art Director: Janet Froelich
Designers: Joele Cuyler, Lisa Naftolin
Artist: Gerhard Richter
Photo Editor: Kathy Ryan

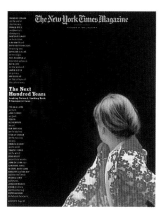

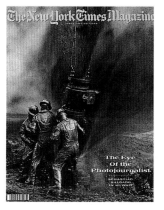

**"The Eye of the Photojournalist"**
Art Director/Designer: Janet Froelich
Photographer: Sebastião Salgado
Photo Editor: Kathy Ryan

**"The Kuwaiti Inferno"**
Art Director/Designer: Janet Froelich
Photographer: Sebastião Salgado
Photo Editor: Kathy Ryan

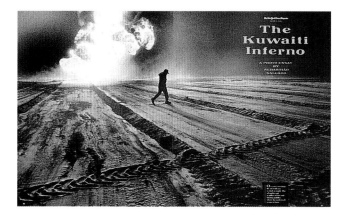

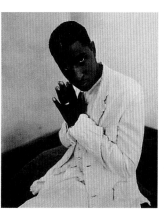

**"The Soul Man of Suburbia"**
Art Director: Janet Froelich
Designer: Catherine Gilmore-Barnes
Photographer: Ruven Afanador/Outline

**"Sleepless"**
Art Director: Janet Froelich
Designer: Joele Cuyler
Photographer: Lisa Spindler
Photo Editor: Kathy Ryan

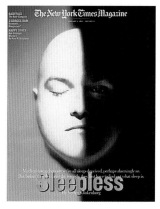

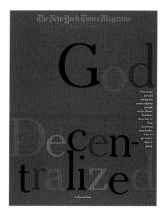

**"God Decentralized"**
Art Director/Designer: Janet Froelich

**"Soft News"**
Art Director: Janet Froelich
Designer: Lisa Naftolin
Photographer: Richard Burbridge
Stylist: Elizabeth Stewart

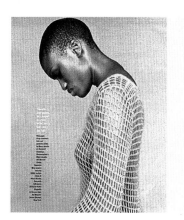

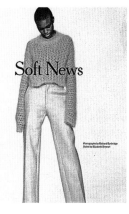

Michael Ian Kaye

An Underachiever's Diary          Benjamin Anastas

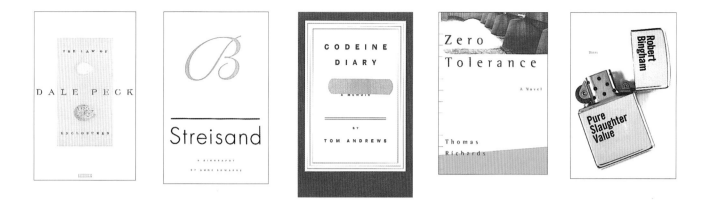

*An Underachiever's Diary*
Designer: Michael Ian Kaye
Client: The Dial Press

**The Law of Enclosures**
Designer: Michael Ian Kaye
Client: Farrar, Straus & Giroux

*Streisand*
Designer: Michael Ian Kaye
Client: Little, Brown

**Codeine Diary**
Designer: Michael Ian Kaye
Client: Little, Brown

*Zero Tolerance*
Designer: Michael Ian Kaye
Client: Farrar, Straus & Giroux

**Pure Slaughter Value**
Designer: Michael Ian Kaye
Client: Doubleday

Book jackets are as much, if not more, susceptible to the vicissitudes of fashion as any other design genre. Since a jacket is both advertisement and package, it must quickly attract a targeted consumer while suggesting the book's content. Sales from browsing currently account for a smaller percentage of sales than they have in the past. And while some famous authors virtually sell themselves, the jacket plays a large role in the appeal of books that do not possess such brand names. There are many exemplars of effective, intelligent and stylish jacket design, but Michael Ian Kaye is the exemplar of visual understatement. And yet his jackets are anything but quiet.

Kaye began designing jackets well over a decade ago, working his way up from an assistant to designer at Penguin, and next to art director of Farrar, Straus & Giroux, to where he is today, design director (for jackets and advertising) at Little, Brown. For the early part of his career he built upon current trends, rejecting the illustrative jackets and covers of the previous generation for the typographic and photographic complexity of the late eighties and nineties. Kaye did not mimic, but he did follow the dominant style while searching to find his own voice.

The jackets Kaye did while at Farrar, Straus & Giroux were moving steadily towards an aesthetic notable for its simplicity. For example, *Elizabeth*, a biography of the English monarch, marked a turning point, for Kaye chose not to embellish but rather use a regal portrait of the Queen, silhouetted against a white background and cropped as if it were cut off at the book's spine. The title was aptly set in an elegant Spencerian script. Rather than evoke a conservative sensibility, the jacket was decidedly contemporary. Maybe it was the black and whiteness of the cover, with just a hint of metallic color in the type; maybe it was the generous use of white space that set it apart. Whichever the answer, at the time Kaye was revisiting some of the modern masters, including Paul Rand, with the realization that simplicity was not the opposite of complexity, but was a means to enable complex messages a chance to be easily decoded.

"Less is more" was not, however, a calculated decision. "I try to find the most succinct way of communicating a concept," explains Kaye. "I allow the concept to dictate the design, and try to keep the design from interfering with the concept." This is clear in the jackets Kaye has designed subsequent to *Elizabeth* for Farrar, Straus & Giroux and Little, Brown, as well as other freelance assignments, where either a photograph is used unadorned with only a modicum of type, or a simple line of type is used without any other visuals. "Simplicity is a direct result of imposing logic and order. In my design it is not a choice," says Kaye. "If I were trying to communicate confusion, I might opt for a busier solution."

While each problem demands a unique visual solution, a large body of Kaye's book work, including *Codeine Diary*, *The Story of Junk*, *Streisand*, *The Underachiever's Diary* and *Zero Tolerance*, involves simple compositions that frame a larger idea. Compared to other jackets, they indicate a decrease in visual intensity in favor of an intellectual rigor. "I have never made a concerted effort to turn down the volume of my work," Kaye concludes. "I think that in my search for effective and direct communication I have eliminated some of the clutter (of which I have never been a fan) and decoration."

Kaye's jackets demand attention because in simplicity there is much power—and eye appeal. But the ultimate reason for his preference for the reductive is simple: "Books are about reading," he acknowledges, "so why would I want to make it difficult to read the title of the book?" So for him the book jacket is a "big logic puzzle" that requires an understanding of what editors, authors and audience expect so he can go acceptably beyond for his own artistic satisfaction.

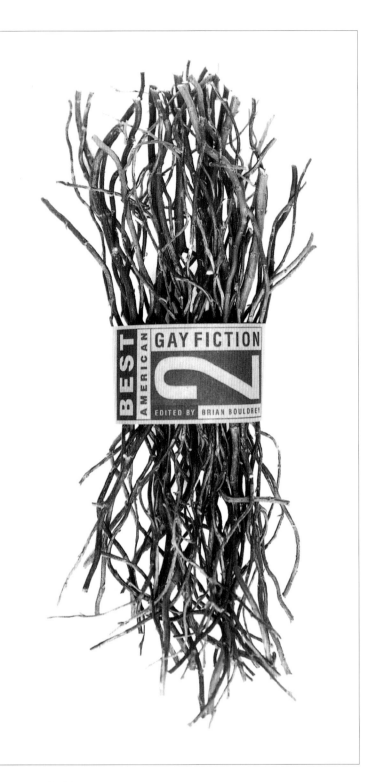

*Sarah Conley*
Designer: Michael Ian Kaye
Client: Little, Brown

*Best American Gay Fiction*
Designers: Michael Ian Kaye, John Fulbrook
Client: Little, Brown

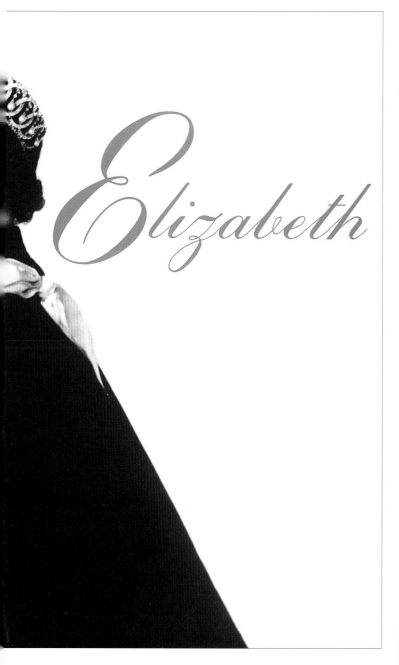

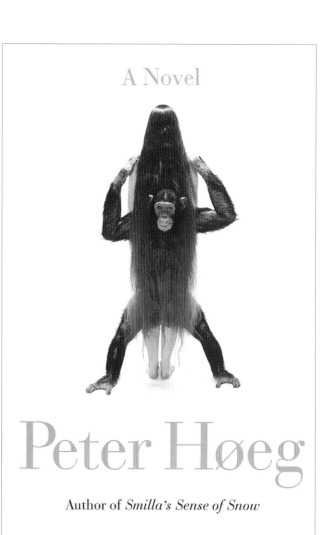

A Novel

Peter Høeg

Author of *Smilla's Sense of Snow*

**Elizabeth**
Designer: Michael Ian Kaye
Client: Farrar, Straus & Giroux

THE STORY OF JUNK

A NOVEL BY LINDA YABLONSKY

**Peter Høeg**
Designer: Michael Ian Kaye
Client: Farrar, Straus & Giroux

**The Story of Junk**
Designer: Michael Ian Kaye
Client: Farrar, Straus & Giroux

# Hoefler Type Foundry

**Didot bracket** (this page)

**Muse logo** (top, facing page)

**Champion Gothic/Welter Weight**
(bottom, facing page)

Readers of *Rolling Stone*, *Harpers Bazaar*, *Sports Illustrated*, *The New York Times Magazine*, and various Condé Nast periodicals may not know Jonathan Hoefler's name, but they are familiar with his face (or faces). As a type designer, the proprietor of Hoefler Type Foundry in New York specializes in designing custom typefaces for publications, and his Hoefler Text family is a fixture of the Macintosh Operating System. At twenty-eight, he has designed over 100 alphabets and is one of the few young type designers to emerge from the Fontographer generation with a passion and understanding for traditional letterforms.

Hoefler is a family man—that is, he is concerned with the way that type families develop. "I don't like to do things that are simply Romans, Italics, Bolds and Bold Italics," he explains. "I'm more interested in doing families of weights or families that evolve in ways that are unconventional, typefaces that can't really be substituted for existing designs."

One of his more illuminating projects is, on the surface, a somewhat dysfunctional type family called Fetish. "You could say it's sort of a postmodern joke on typography," he qualifies, "but it's also kind of a commentary on some of the things that I find curious and questionable about contemporary typography." Specifically, the quirks and complexities that obstruct legibility.

Fetish 338, Hoefler's first design in this series, is moreover a critique of the "eccentricities" that are, he asserts, associated with classicism: "The face is overly flowered and ornamented, and is rococo and baroque at the same time." Basically it is a put-on of a typeface that forces users to address the nature of typographic eccentricity. Hoefler likes to teach—and learn—through type, and designed the next in the series, Fetish 976, as a parody of those functional faces used for specific tasks, like telephone directory body text. "Fetish 976 is designed in a way that aestheticizes the

idea of function," explains Hoefler. "It contains many of the aspects of use; things like ink traps to allow for reproduction in small sizes on bad paper printed on web-offset presses. But rather than using these things functionally, the theme of the typefaces is to actually be an ink trap." The irony is that these attributes are used in unnecessary ways that seem to be technical and functional, but are in fact technically and functionally ridiculous. But despite all these excesses, there is also a sublime minimalist quality.

In the twenties and thirties, designing typeface catalogs and specimens was an art in itself that atrophied in the sixties and seventies. With the advent of desktop publishing in the late eighties, specimen sheets and books have returned with a vengeance and Hoefler's are—in contrast to digital type foundries like Plazm, GarageFonts, and Elliott Earls whose specimens are revelries in raucousness—designed on a classical foundation that stresses elegance and utility. "I like to play with the form aesthetically; I try to create some [specimen] composition that I think gets across the point of the typeface," says Hoefler about specimens that recall the work of traditional craftsmen/designers, Rogers, Updike and Goudy, but are not nostalgic reprises of them.

The Hoefler Type Foundry's new type catalog/magazine, titled *Muse* (perhaps a satiric reference to the title of the "experimental" type magazine and conference, FUSE), has the quality of classical specimens of the nineteenth and early twentieth centuries, but is not a carbon copy. Hoefler follows the structural and aesthetic dictates of this era, but his revivalist sensibility is governed by mastery of contemporary methods and manners. *Muse* so consciously avoids contemporary trends that it is set apart from fashion while not anachronistic. Simplicity is not simply a conceit, but a natural outgrowth of Hoefler's historical understanding.

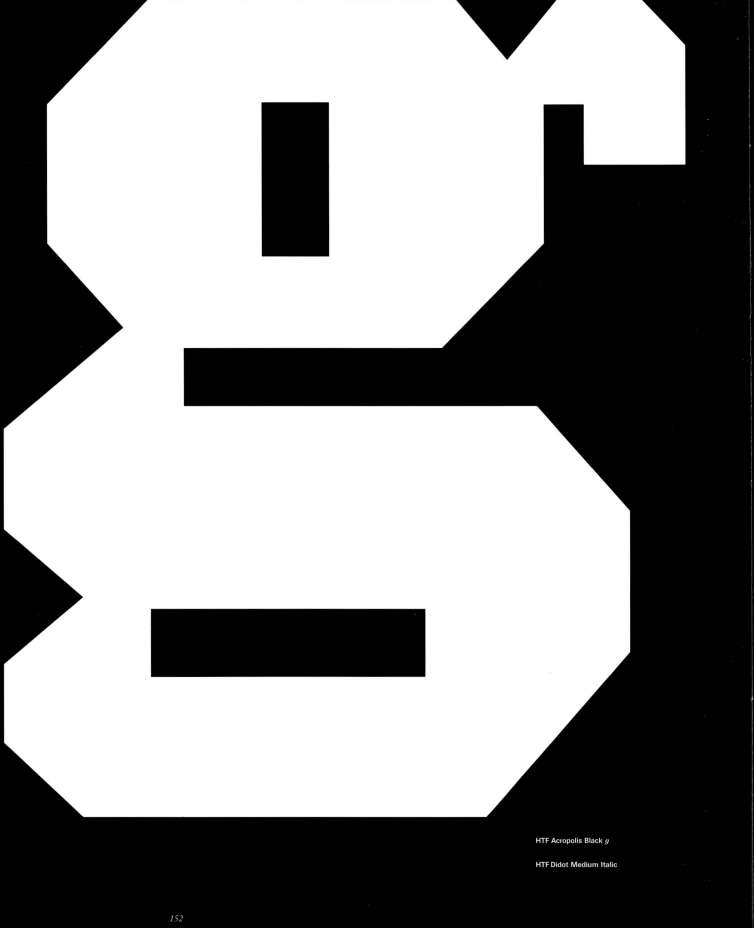

HTF Acropolis Black *g*

HTF Didot Medium Italic

# MIL Rétif
# FOIS Parez
# NEUF Soirées
# SORTIE Rafistoler
# ROSAIRE Scrupuleux
## CAVALIERE Empêchement
## DESCRIPTIONS Concentus Musicus
### WARBURTONSMITH Mesoamerican Cultures
### THIS PRACTICE HELPS Created For Use at 144 Point
### REVIVE THE TYPEFOUNDERS' Intermediate Typefaces can Be Created
### PRACTICE OF CUTTING DIFFERENT Which are Suited to Use over a Particular
### DESIGNS FOR DIFFERENT SIZES: SINCE A Range of Sizes. On this spread, there are actually
### TEXT SIZE MASTER WAS CREATED FOR IDEAL Fourteen typefaces, seven sizes each for Roman and Italic
### USE AT TEN POINT, AND A DISPLAY SIZE MASTER WAS Thus as the type gets Bigger, the Hairlines remain Delightfully Thin

# Copyright Notices

# Subject Index

Action/reaction theory, 8
Advertising, 19, 28-33
Airborne theory, 8
Alpha theory, 8
Anderson, Charles Spencer, 20, 22
Annual reports, 34-43
    Chicago Board of Trade,
    130-133
Art Deco style, 20
Art Nouveau style, 14, 20
Attelier Populare, 21

Basel School of Design, 15
*Basel School of Design and Its*
    *Philosophy: The Armin Hofmann*
    *Years 1946-1986, The,* 18
Bass, Saul, 19, 85
Bauhaus, the, 13-15, 20, 54
Beall, Lester, 14, 19, 85
Bernhard, Lucian, 116
Blackletter typeface, history of,
    12-13
Book covers, 44-53
Book design, 139
Book jackets, 44-53, 147
Books, 54-63
Bradley, Will, 12-13
Brochures, 64-75
Brodovitch, Alexey, 20
Burtin, Will, 14
Business graphics. *See* Modern
    design, corporate

Carson, David, 21-22
Cassandre, A. M., 20
Catalogs, 64-75
Circle of New Advertising
    Designers, 13
Classicism, in type, 127
Constructivism, 65
    design influence of, 13
Cooper Black typeface, use of, 131
Cooper, Oswald, 131
Coyne, Richard, 23
Cranbrook Academy of Design, 21
Cubism, design influence of, 13

Dada, 20
*Dance Ink,* design of, 127
de Stijl, 13, 21, 54
Deconstruction, 8, 21
die Neue Grafik, 15
Elementare form, 12
Elementare Typografie, 13
*Emigre,* 21
Experimental design, development
    of, 13

Federico, Gene, 19
Fetish type family, described, 151
Form, elementare, 12
Friedman, Dan, 20
Frutiger, Adrian, 18
Futura typeface, origin of, 18
Futurism, design influence of, 13,
    20

Gage, Bob, 19
Garamond, Claude, 12
Gerstner, Karl, 18
Gothic typeface, origin of, 12
Graphic design, history and
    evolution of, 12-22

*Graphic Designer and His Design*
    *Problems, The,* 15
Greiman, April, 20
Grid, introduction of the, 15
Gutenberg, Johannes, 12, 127

Heartfield, John, 17
Helvetica typeface
    corporate uses of the, 19
    in Swiss style, use of, 15
    origin of, 18
Hiebert, Kenneth, 18
Hoefler text type family, use of, 151
Hoefler Type Foundry, 150-153
Hoffman, Edouard, 18
Hofmann, Armin, 15, 18
Huxley, Aldous, 12

Identity, logos as, 85-93
*Illustrated History of Writing and*
    *Lettering, An,* 12
Incunabula, revival of, 12
International Style, the, 15

Jenson, Nicolas, 12

Kauffer, E. McKnight, 20
Krone, Helmut, 19

Le Corbusier, 13
Legibility, discussed, 12
Licko, Zuzana, 21
Lionni, Leo, 14
Logos, evolution of, 19, 85
Lois, George, 19
Lubalin, Herb, 23
Lustig, Alvin, 14-15

Magazines, 94-103
    *Dance Ink,* 126-129
    *Mademoiselle,* 95
    *New York Times,* 9, 143-145
    *Portfolio,* 95
    *Seventeen,* 95
Majoor, Martin, 127
Miedinger, Max, 18
Miller, J. Abbott, 127
Modern design, 14-15
    corporate, 19
Moderne design. *See* Modernism
Modernism, 14-15, 127
Mondrian, Piet, 21
Morison, Stanley, 12
Morris, William, 12
Movements
    constructivism, 65
    Dada, 20
    futurism, 13, 20
    modern design, 14-15, 19
    modernism, 14-15, 127
    postmodernism, 7, 19-22
    Vienna Secession, 135
    Wiener Werkstatte, 135
Müller-Brockmann, Josef, 15
*Muse,* type catalog, 151
Music, 76-83

*Neue Grafik,* 15, 18
New Bauhaus, the, origin of, 14
New typography, the, 13-15
New wave design, 8, 20
*New York Times Magazine,* 9
    design of the, 143-145

Nitsche, Erik, 19, 85
Novelty typefaces, uses of, historic,
    13

Object poster, 116
*See also* Posters

Packaging, 104-113
Photography, conceptual studio,
    introduction of, 19
Postcards, promotional, 135
Posters, 114-123
Postmodernism, 7, 19-22
*Printing of Today*, 12
Promotional campaign, Champion
    Paper, 135
Psychedelic poster, 116
*See also* Posters
Punk design, 8

Rand, Paul, 14, 19, 85, 131, 147
Record albums, 76-83
Renner, Paul, 18
Retro design, 8, 20, 22
Roman typeface, origin of, 12
Ruder, Emil, 15, 18

Sachplakat, 166
Salisbury, Mike, 22
Scala typeface, use of, 127
Schools
    Bauhaus, the, 13-15, 20, 54
    cubism, 13
    de Stijl, 13, 21 54
    New Bauhaus, the, origin of, 14
Schuiterna, Paul, 14
Styles
    Art Deco, 20
    Art Nouveau, 14, 20
    deconstruction, 8, 21
    Swiss, 15, 18-20, 85
    Victorian, 12-14, 20
Sutnar, Ladislav, 14, 16, 65
Swiss style, 15, 18-20, 85

Taubman, William, 19
Textura typeface, origin of, 12
Theories, of change, 8
Thompson, Bradbury, 14
Tory, Geofroy, 12
Tschichold, Jan, 12
Typeface catalogs, design of, 151
Typefaces
    design of, 12, 18
    for publications, 151
    Hoefler Type Foundry, 151-153
    origins of, 12
    sans serif, 18
    uses of, historic, 12-21

Univers typeface, origin of, 18

Van der Rohe, Meis, 11
VanderLans, Rudy, 21
Victorian style, 12-14, 20
Vienna Secession, 135

Wiener Werkstätte, 135
Weingart, Wolfgang, 20
Wolf, Henry, 22

Zeitgeist, and design, relationship
    between, 8, 135

# Index of Design Firms

Adams Morioka, 8, 114-115, 121
Anderson, Charles Spencer, 20, 22
Anderson, Gail, 98
Arnett, Dana, 131

Baker, Richard, 145
BlackDog, 93, 114, 116
Bordwin, Gabrielle, 47
Boychuk, Tracy, 54
Bruno, Claudia, 101

Cahan & Associates, 8, 36-41, 67, 74, 106
Capitol Records Art, 78-79
Carin Goldberg Design, 44, 47, 52
Carmichael Lynch Thorburn, 64, 68, 86, 91
Carpenter, Andrew, 51
Carson, Carol Devine, 48
Carson, David, 21-22
Chantry, Art, 77, 80, 82
Charles S. Anderson Design Co., 85, 87, 90
Chermayeff & Geismar Inc., 19, 85, 89
Concrete, 103
Corral, Rodrigo, 50
Creative Services for Mercury Records, 81
Cuyler, Joele, 144-145

David Carson Design, 7, 117
De Wilde, Barbara A., 47, 49, 52
Delessert & Marshall, 51, 88
Desgrippes Gobé & Associates, 107
Design Machine, 102, 115, 120
Design/Writing/Research, 51, 57, 59, 61, 96, 127-128
DiGrado, Kathleen, 52-53
Doyle Partners, 9, 45, 47, 53, 135-137
Doyle, Stephen, 135
Drenttel Doyle Partners, 135
Drenttel, William, 89, 117
Drummond, Stacy, 54

Emigre, 7
Eric Baker Design Associates, 73

Fahrenheit, 114, 117
Ferguson, Archie, 47, 51
Fink, Anne, 56
Frankfurt Balkind Partners, 75
Free Associates, 66
Froelich, Janet, 143-145
FSG Design Works, 48
Fulbrook, John, 148

Gall, John, 47, 53, 81
Gilmore-Barnes, Catherine, 142, 145
Goldman, Leslie, 49, 51
Greiman, April, 20

Haley Johnson Design Co., 71, 86-87, 91-92, 118
Helfand, Jessica, 89, 117
Hessler, Geraldine, 98
Hoefler, Jonathan, 151-152
Hoefler Type Foundry, The, 150-153
Hornall Anderson Design Works, Inc., 69, 110
Hudson, Judith, 81

Jager Di Paola Kemp Design, 89
James Victore Inc., 52, 120, 123
JNL Graphic Design, 71
Judah, 82

Katz, Maria, 82
Kaye, Michael Ian, 95, 117, 146-149
Kelly, Jerry, 138-141
Keyton, Jeffrey, 54
Kidd, Chip, 46, 52
Knoll Graphics, 69

Leimer Cross Design, 40-42
Leo Burnett USA, 28
Leonhardt Group, Inc., The, 110
Licko, Zuzana, 21
Lippa Pearce Design Ltd., 66, 111
Liska and Associates, 92
Louise Fili Ltd., 50-51, 108, 112

M&Co., 29
M. Skjei Design Co., 56
Michael Mabry Design, 31, 66, 70, 104, 113

Naftolin, Lisa, 144-145
Number Seventeen, 29

Office of Paul Sahre, 45, 49-50, 87, 114, 119
Open, 31, 78-79, 105

Pentagram Design, 8, 48-49, 75, 87, 110, 116-117, 120, 143
Pike, Eric A., 101
Planet Design Company, 67, 90-91
Push Pin Studios, 20

Ratchford, Patti, 47
Roger Black Inc., 9

Sagmeister, Inc., 9, 83, 92
Sahre, Paul, 97
Salisbury, Mike, 22
SamataMason, 37
Scher, Paula, 143
Seasonal Specialties LLC, 112
Slatoff & Cohen Partners Inc., 84, 100
Socio X, 31, 73, 94
Sony Music Creative Services, 79
St. Hieronymous Press, 122
Steven Brower Design, 53
Studio d Design, 88-89, 112
Studio Pepin, 111, 113, 121

Tolleson Design, 42, 90, 111
2x4, 72

Smith, Tyler, 72

Vanderbyl Design, 65, 67, 73, 115
VanderLans, Rudy, 21
Vignelli Associates, 107, 112
Visual Asylum, 88
VSA Partners, 43, 123, 131-133

Werner Design Werks, Inc., 34, 69, 109, 121
Woodward, Fred, 63, 98
Worksight, 71

# Index of Clients

A. Colish, Inc., 141
Adaptec, Inc., 36
Addison-Wesley, 49
AIDS Project Los Angeles, 121
AIGA, 95, 117
AIGA Baltimore, 114
AIGA Colorado, 116, 118
Alcatraz Ale, 106
Alfred A. Knopf, 45-49, 51-53
Altoids, 28
American Broadcasting Co., 29
American Institute of Architects,
     New York, 117
American Institute of
     Architecture/LA, 115
Amphetamine Reptile Records, 82
Ann Taylor, 107
Apollo Ale & Lager, 106
Association for Children's
     Healthcare of Minneapolis, 64

Ballet-Tech, 116
Beantown Soup Co., 112
Belkowitz Photography + Film, 89
Biblio's, 115
Birch Lane Press, 48
Birkenstock, 111
Bollati Boringhieri, 51
Boots Company Plc., The, 111
Buck, Jackie, 88

C. Walsh Theater, Suffolk
     University, 117
Cadence Design Systems, Inc., 39
Cafe 222, 88
California College of Arts and
     Crafts, 67, 115
Capitol Records, 78-79, 83
Carmichael Lynch Thorburn, 86
Center for Research in Applied
     Creativity, 66
Champion Paper, 135-137
Chicago Board of Trade, 130-133
Citizens for a Smoke-Free World,
     117
City Bakery, 117
Coca-Cola, 31
Cooper Hewitt National Design
     Museum, 9
COR Therapeutics, Inc., 41
Creative Editions, 51
*Creativity*, 105
Crider, Dave, 77, 80
Crown Publishing, 47

Daniel Proctor Photography, 66
Dayton Hudson Corporation, 121
DDD Gallery, 123
Design and Art Directors
     Association, 66
Designing New York, 120
Dial Press, The, 8, 147
Doubleday, 147
Drenttel, William, 89, 117
Duggal, 31

Earthshare, 29
East 42nd Street Salon, 87
Effect, 90
El Paso Chili Co., 104
Estrus Records, 77, 80
Etec Systems, Inc., 8
Expeditors International of
     Washington, Inc., 41

Farrar, Straus & Giroux, 48-51,
     147, 149
*Fashion Reporter*, 94
Fink, Anne, 56
Fordham University, 75
Fujiwara Opera, Tokyo, 121

Gallimard, 88
GATX Capital Corporation, 42
G. H. Bass & Co., 110
Gilbert Paper, 73
GKV Design, 87
Globe, The, 87
Goodman, David, 90
Grove Press, 45, 49
GVO, The Product Definition &
     Development Company, 74

Harley-Davidson, Inc., 43, 123
Harmony, 52
Harry N. Abrams, 61
Harvard University Graduate
     School of Design, 114
Heartport, Inc., 37
Helfand, Jessica, 89, 117
Heltzer Incorporated, 92
Horowitz, Glenn, 139
*Icon Thoughtstyle*, 102
Indochine, 109
International Interior Design
     Assoc., 103
International Typeface Corporation,
     9

Jager Di Paola Kemp Design, 89
James H. Barry Co., The, 70
Jewelstar, 91

Kawade Shobo Shinsha, 111
Kelly-Winterton Press, 140
Knickerbocker, 97
Knoll, Inc., 69, 72
K-RATION, 90

Le Duc Allez, Paula, 113
Levi's, 31
Lincoln Center Theater, 100
Lincoln National Corporation, 37
Little, Brown, 46-47, 63, 147-148
Lohf, Kenneth A., 139-140
Louis, Boston, 72

Mabry, Emily, 66
Marchesi Fassati di Balzola Winery,
     112
Marsilio, 45, 47, 50
Matre Productions, 91
Mercury Records, 81
Mill Valley Film Festival, 114
Minneapolis Downtown Council,
     68
Minnesota Children's Museum, 8
Mohawk Paper Mills, Inc., 69, 75
MTV Off Air Creative, 54
Museum of Modern Art, New
     York, The, 59
Musicland Stores Corp., 34

National Broadcasting Co., 29
New 42nd Street Inc., The, 89
*New York Times Magazine*, 9,
     142-145
Nonesuch Records, 81
Nordstrom, 110

Oak Technology, Inc., 38
*Obscure Objects*, 102
Ockenfels3, Frank, 85
Olea Incorporated (South Africa),
    113
Out of Hand Tileworks, 86

Pantone, 73
Parallax Theater Company, 120
Penwest, Ltd., 42
Performing Arts Chicago, 71
Planet Design Company, 67, 91

Ralph Lauren, 87
Random House, 47, 51
redgroup, 71
Robert Talbott Inc., 73

Salisbury Studios, 90
Scribner, 44
Seh Importers, 104
Shakespeare Project, The, 120
sidewalk.com, 33
Skjei, M., 56
Slamdance International Film
    Festival, 8, 114
Smithsonian Folkways Recordings,
    78-79
Smith Sport Optics, 110
Solomon R. Guggenheim
    Foundation, The, 57
Sony Classical, 79
Sony Music Entertainment Inc., 79
St. Hieronymous Press, 122
Stinehour Press, 139-140
Strathmore, 71
Sub Pop, 80
SunDog, Inc., 69

Target Stores, 85, 109, 112
Tea for Two, 92
Teknion, 65
Terrence Higgins Trust, The, 111
Terron Schaefer, 107
Time Warner Inc., 85
Toto NCG, USA, 92

UCLA, 121
University of the Arts, The, 120

VH1, 69
Vichon Winery, 67
Vintage Books, 47
Vitra, 51

Warner Bros. Records Inc., 83
Weil, James L.,140
Wexner Center for the Arts, The
    Ohio State University, 122
Whitney Museum of American Art,
    105
Wieden & Kennedy, 31, 33
W. W. Norton, 47

Xilinx, Inc., 40

Zurich Reinsurance Centre
    Holdings, Inc., 40